ASHEVILLE

IMPRESSIONS Photography By Bob Schatz
Foreword By Fred Chappel

FARCOUNTRY
PRESS

Above: Morning fog shrouds the French Broad River.

Right: An overlook near Mount Pisgah provides a splendid view of dawn lighting the valleys and mountains that surround the Blue Ridge Parkway.

Title page: A boathouse awaits its vessels on the Biltmore Estate's Bass Pond.

Cover: Early morning light accentuates the geometric angles of Asheville's skyline against the rounded contours of the surrounding mountains.

Back cover: Life-size bronze statues of folk musicians playing a fiddle and a banjo exemplify Asheville's Appalachian heritage. The one-of-a-kind statues are along the Urban Trail, in front of the Civic Center.

ISBN 10: 1-56037-432-2
ISBN 13: 978-1-56037-432-9

© 2008 by Farcountry Press
Photography © 2008 by Bob Schatz

For more information about our books, write Farcountry Press, P.O. Box 5630, Helena, MT 59604;
call (800) 821-3874; or visit www.farcountrypress.com.

Created, produced, and designed in the United States.
Printed in China.

12 11 10 09 08 07 1 2 3 4 5 6

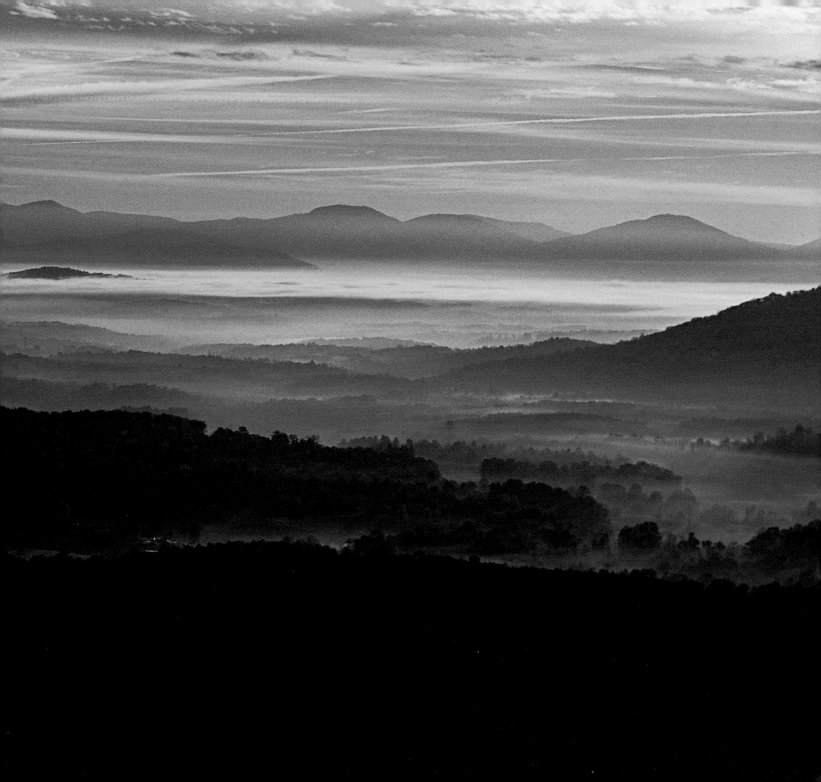

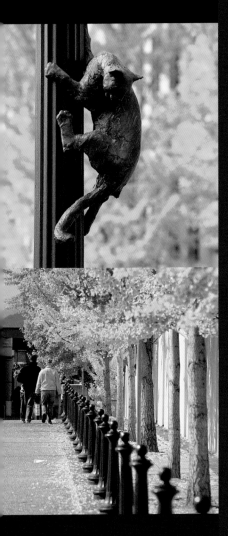

The pedestrian-friendly design on Wall Street, along Asheville's Urban Trail, encourages a stroll through the popular downtown shopping district. One of the amusing sculptures found here is *Cat Walk* by Vadim Bora.

FOREWORD
By Fred Chappel

Asheville is an October town.

Lying in a hilly plateau in the forested mountains of western North Carolina, it is encircled, come autumn, by a quilted march of mountains on all sides. Maples and oaks, beeches and hickories, dogwoods and ash fling upon the slopes great mixed swatches of color so bright and interwoven that the display would bewilder the most skillful Impressionist painter. All day long the scarlets and saffrons and emeralds and oranges change, gleaming gemlike on the western hills in the early morning, glowing bravely at midday horizon to horizon, growing plummy, velvety, as twilight mutes the hues to the east.

The town seems to absorb the moods of the transfiguring light. In the early morning at the Farmers' Market, bustle and bright chatter enliven the unloading and cheerful hawking of late corn and tomatoes, leaf-green okra, huge mounds of red-orange pumpkins and cushaws, and basket after basket of apples brought down from hilltop orchards, the Delicious both red and yellow, of course, but also the older strains no longer fashionable, the Ben Davis, the Winesap, the modest speckled Black Twig, and those streaky, little pillow-shaped fruit known locally as "horse apples."

Five or six times I have begun a Loafer's Day at the Farmers' Market just south of town, drinking watery black coffee, sampling various fried pies (pumpkin, sweet potato, apple butter) offered by freckled farm wives and trying to converse with taciturn farmers who come in from remote fields to have a shy little nibble at social life.

Midmorning I would head back to town along Amboy Drive bordering the French Broad River, over which tall willows—the last trees to lose their leaves in fall, the first to regain them in spring—sweep gracefully in the breeze like the crinoline skirts of a vanished culture.

This route brings me into the section of Asheville called Biltmore Village, a dozen or so square blocks of posh clothing shops, chocolate counters and dainty tea houses, and restaurants ranging in character from chain Texmex to upscale Mediterranean. The Village would be stirring to life by now, with shopkeepers brushing off entrances and raising blue-striped awnings, delivery trucks disgorging boxes large and small, trucks from local farms and dairies stacking produce. Tourists would already be in evidence, standing before expensive displays of clothing and jewelry and girding up to enter the vast Biltmore Estate across the road, there to visit George Vanderbilt's sum-

mer chateau, Biltmore House—another reminder of a culture that departed but left a signature immensely visible.

Noon is a wise time to follow Biltmore Avenue north to Pack Square, the center of Asheville. Here is cuisine of various character and ethnicity, from hip-mod, post-Nouvelle to spicy Hispanic to mellow Asian. The Square now will be vivid, as figures and faces reminiscent of Haight-Ashbury in the days of 1960s glory flock the sidewalks, plinking guitars, spouting politics, or parading proudly in downscale finery, patched and happily tattered. "Trashistas" the latter strollers are sometimes labeled. Sparsely intermingled with these exotics will be native folk musicians whose preferred instruments are fiddles, upon which they unabashedly scrape out "Arkansas Traveler" or "Turkey in the Straw." These indigenous individuals are regarded by the urban newcomers as being akin to holy prophets.

I would take a leisurely lunch before footing it over to Lexington Avenue to browse antiques barns, head shops, used book dealers, and funky bars. A sleepiness pervades this scene, an air of patient anticipation. Lexington is livelier after dark, but its afternoon charm is undeniable. Then up steep Walnut Street to cultivate the afternoon with coffee, books, and periodicals at renowned Malaprop's, an important east coast Mecca for writers on tour or off, for readers ardent or laid back.

Five o'clock I judge a sufficiently proper hour to begin a meditative wine-bar saunter to the hotel, where I would join spouse Susan, sister Becky and her husband Ed, to find dinner and maybe music or theater afterward. There is always a solid menu of evening diversions to ponder, from bluegrass to classical chamber music, from Shakespeare to raunchy contemporary plays. I think up choices as I wander, standing at the bar with a glass of Sancerre, taking stock of the office workers, reporters, attorneys, students, and tourists who come in for aperitifs. Each group has its own dress code, with tourists the most adventurous in costume.

The crown of mountains would have toned down its brilliant colors, mellowing the scarlet to rose, the saffron to gold. Now I would return to our hotel room to dress for dinner and Susan would ask me three questions:

"Where did you go?"

"Nowhere," I would reply truthfully. "Everywhere."

"What did you do?"

"Nothing. Everything."

"So Asheville hasn't changed much?"

"Well," I would say, "yes and no."

Fred Chappel, poet laureate of North Carolina from 1997 to 2002, grew up in the mountains near Asheville. His published works include seventeen collections of poetry, eight novels, two books of short fiction, two books of essays, and a multi-genre reader.

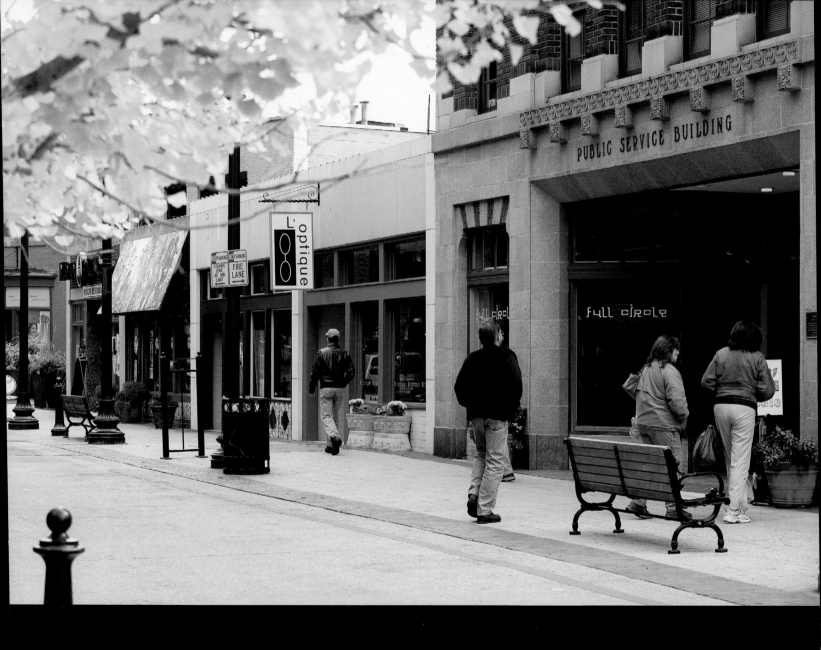

Asheville's daily Farmers' Market attracts vendors with diverse wares. The temperate climate means there are seasonal items year round, such as fruits and vegetables, as well as items unique to the area: mountain crafts, jams, jellies, preserves, and sourwood honey. Every autumn, the offerings include beautiful multicolored corn, fresh crispy apples, and blossoming chrysanthemums of every hue.

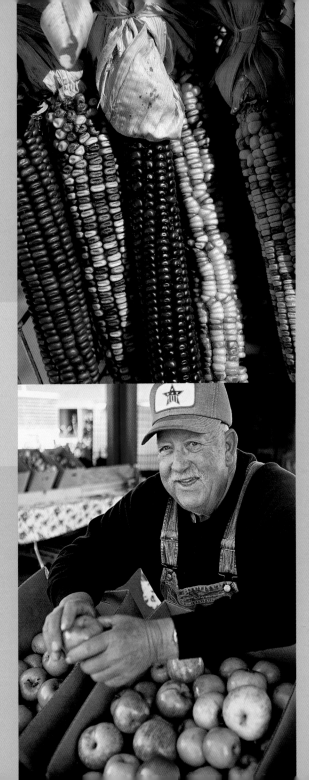

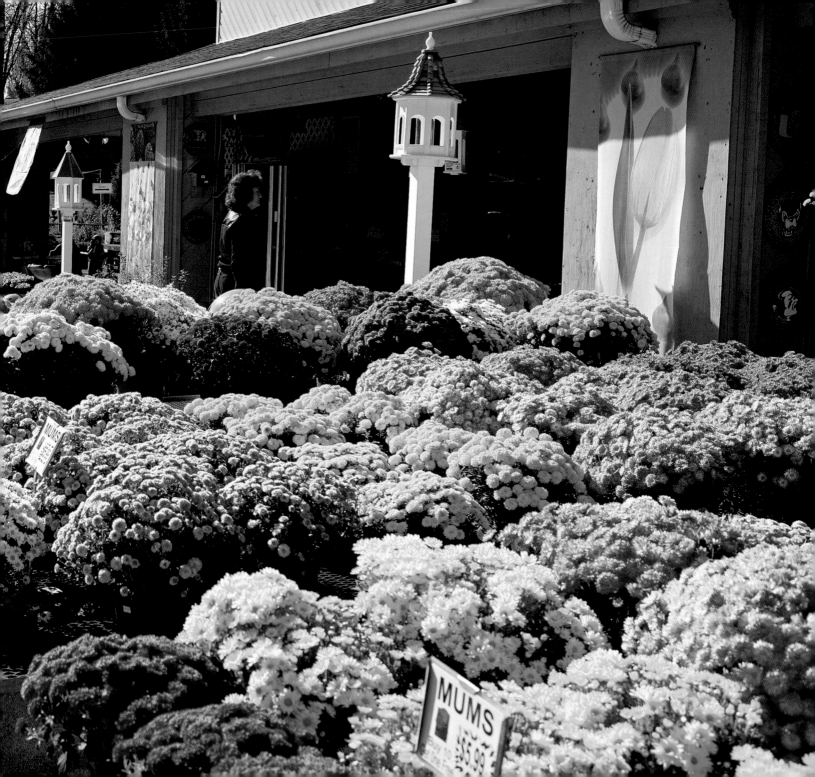

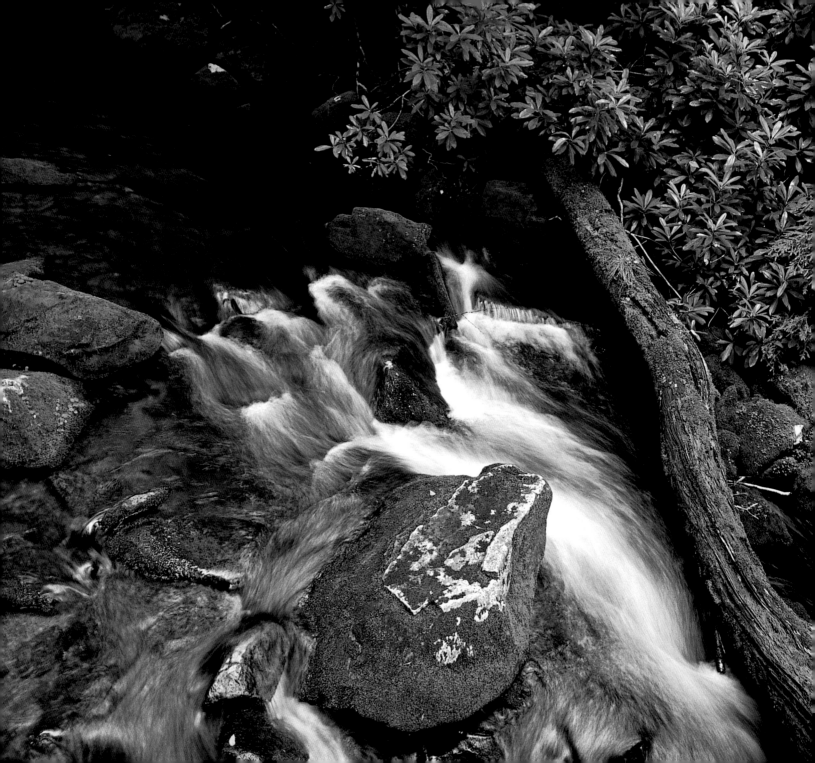

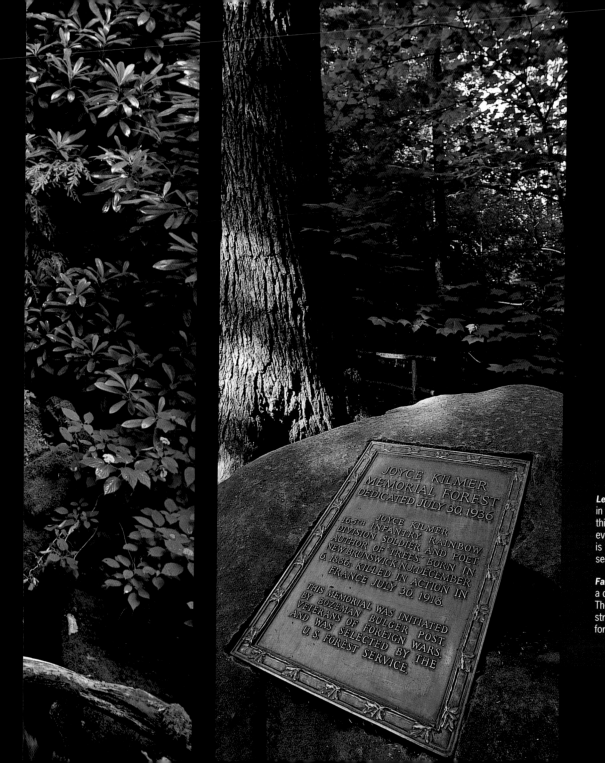

Left: A plaque in Joyce Kilmer Memorial For[est] in the Nantahala National Forest, commeme[orates] this poet and soldier who wrote about the everyday beauty of nature. His best-known [poem] is "Trees," which begins "I think that I shall n[ever] see/ A poem lovely as a tree...."

Far left: Little Santeetlah Creek cascades d[own] a drop in the Joyce Kilmer–Slickrock Wilder[ness]. The 17,394-acre wilderness protects pristi[ne] streams and preserves old-growth cove har[dwood] forest, including some trees nearly 450 yea[rs old.]

Above, right: Westminster Peal Bells hang ready to sound the call on the hour and half hour at The Cathedral of All Souls, in Biltmore Village. The church was consecrated in 1896.

Below, right: Attention to architectural details makes the structures in Biltmore Village an enduring attraction. George Vanderbilt planned this unique town to complement his 125,000-acre estate.

Far right: The dome of Asheville's First Baptist church rises above foliage just bearing the first hints of autumn.

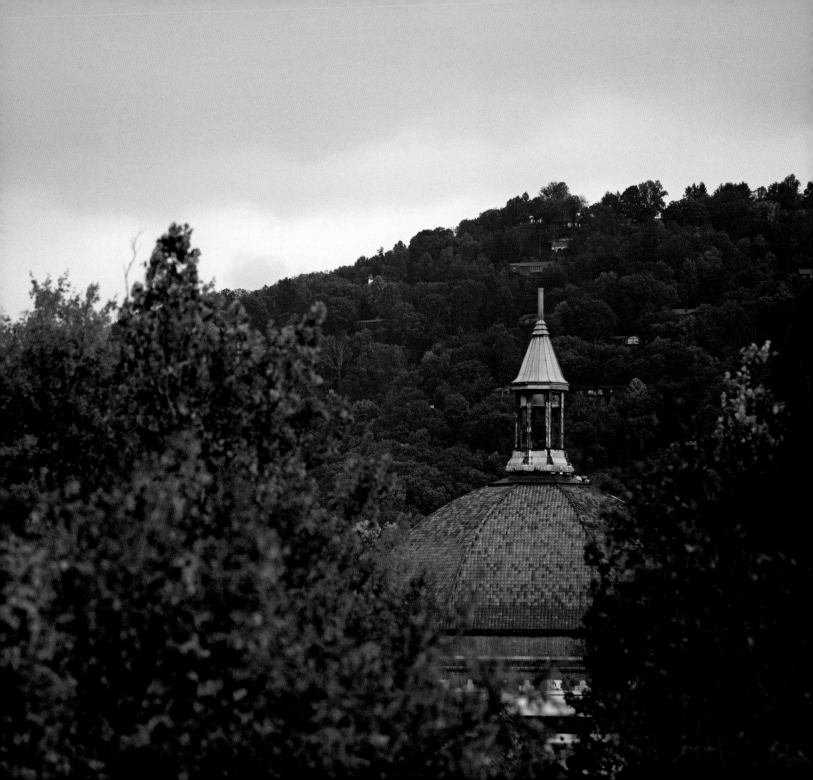

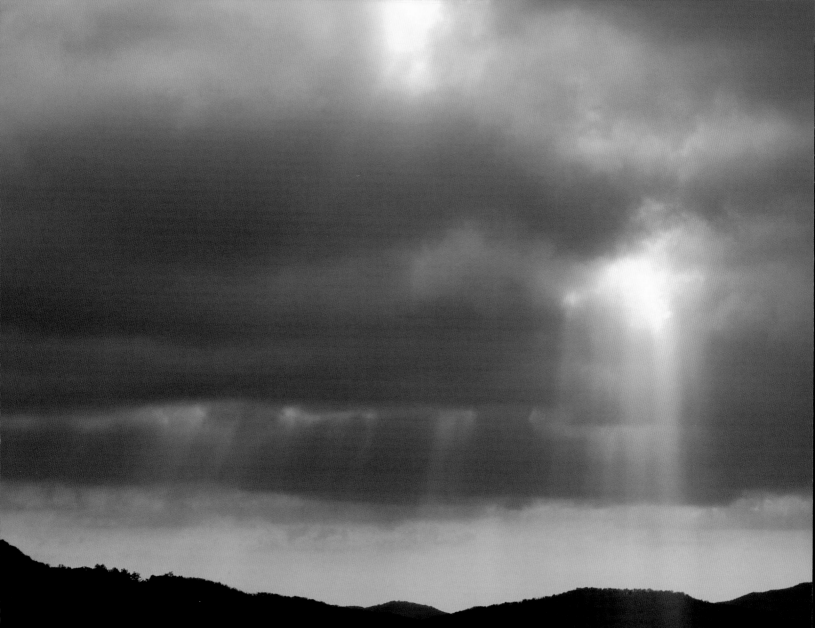

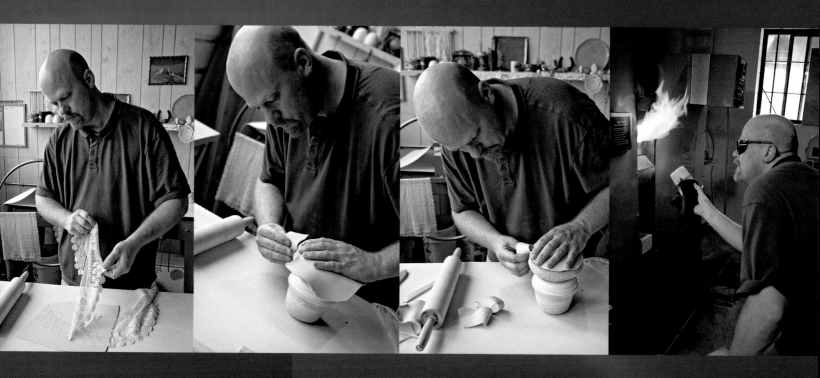

Above: Ceramic artist Michael Hofman creates a one-of-a-kind porcelain pot in his studio in the River Arts District.

Background photo: "God rays" stream through a break in the clouds, seen from the Blue Ridge Parkway.

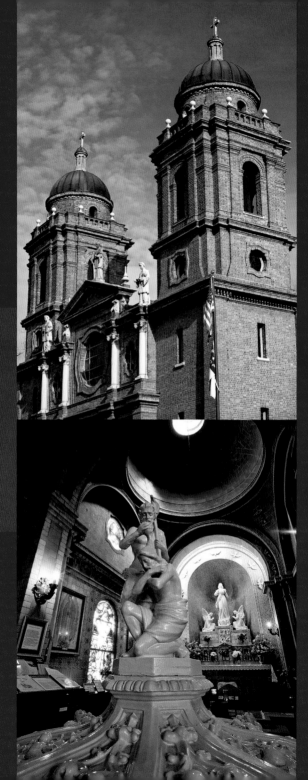

The Basilica of Saint Lawrence is the only church designed and built by the renowned architect Rafael Guastavino (whose crypt is found at the back of the chapel), in collaboration with R. S. Smith. The unique Spanish renaissance architecture of this Holy Roman Catholic Church features immense stone foundations and a solid brick superstructure, with a remarkable freestanding curved dome. Not a single beam of wood or steel supports the structure, completed in 1909. Every wall, floor, ceiling, and pillar is of tile or other masonry materials, including the striking domed roof which has a protective copper cover. Nearly every stained-glass window came from Germany.

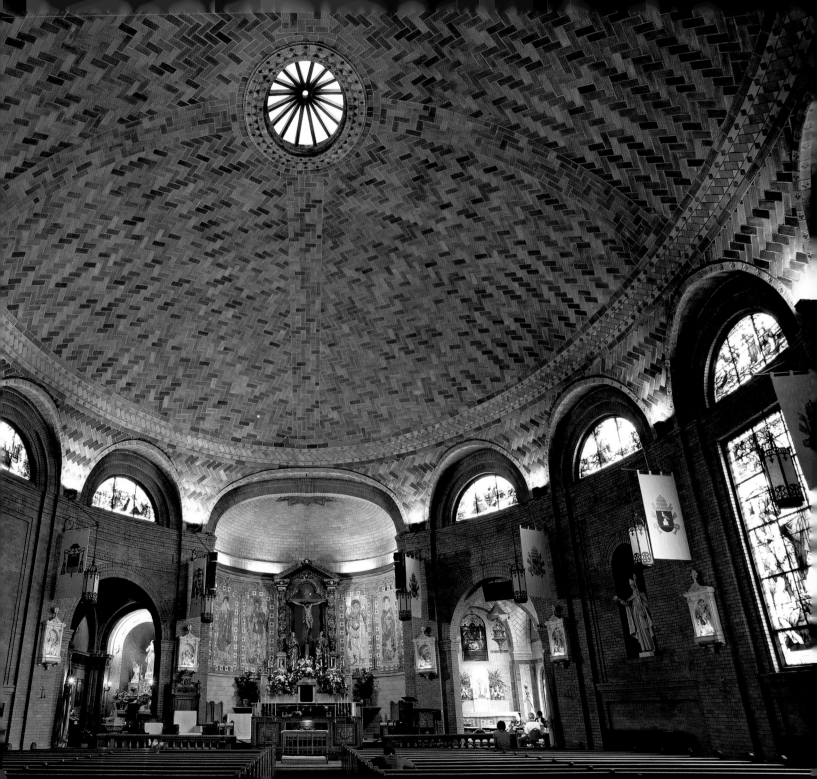

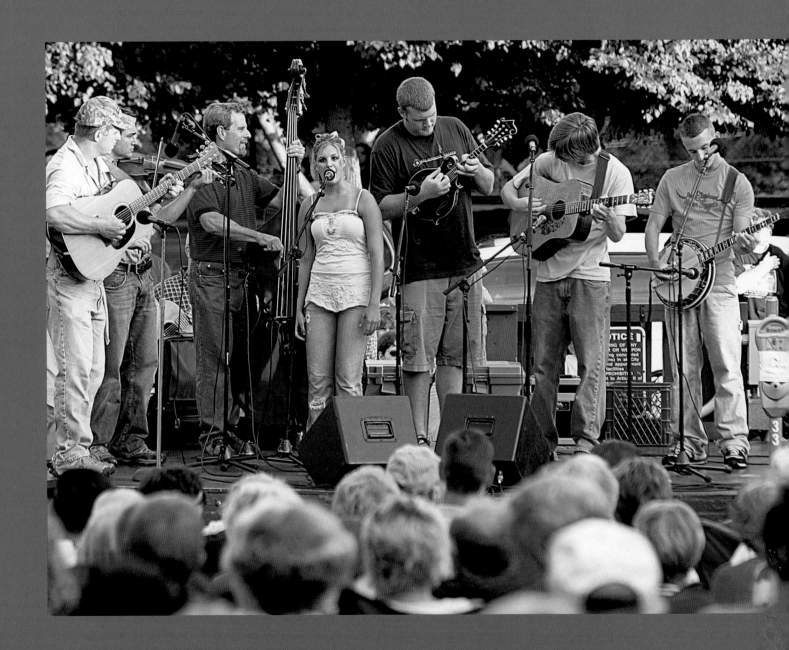

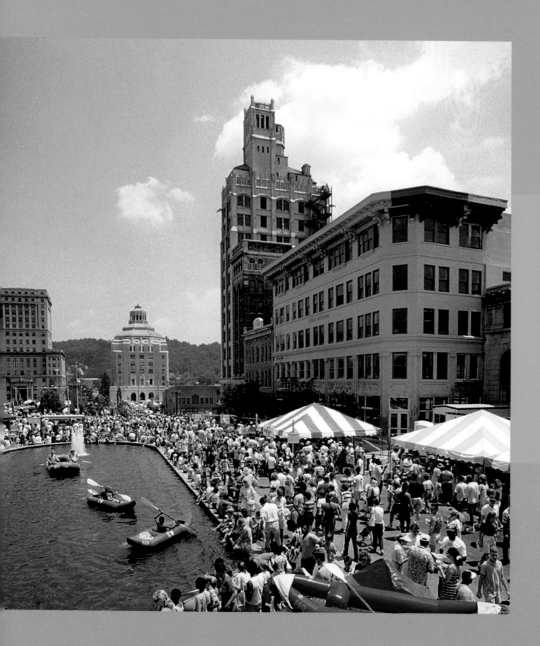

Left: More than 300,000 celebrants throng to the Bele Chere Festival in downtown Asheville during the last full weekend in July. This annual free street festival is the largest in the Southeast. Bele Chere means "beautiful living."
PHOTO COURTESY OF ASHEVILLE CONVENTION & VISITORS BUREAU

Facing page: Shindig on the Green is a free summerlong festival that celebrates the region's heritage. Families bring lawn chairs and set up around sundown, then sit back to enjoy string bands, clogging, and mountain dancing.
PHOTO COURTESY OF ASHEVILLE CONVENTION & VISITORS BUREAU/TONY MARTIN

Below, left to right: A narrow passage and 185 stairsteps let you sneak right into a vertical fault joint in the otherwise dense granite of Needle's Eye, at Chimney Rock Park. Wild Cat Trap is a tight squeeze along the Skyline/Cliff Trail Loop. The dam on the Rocky Broad River that created Lake Lure was completed in 1926.

Facing page: Not for the fainthearted, Chimney Rock rises 315 feet above its surroundings and affords an unsurpassed view of the hardwood forest and Lake Lure in Hickory Nut Gorge. Clear days provide vistas that extend as far as 75 miles.

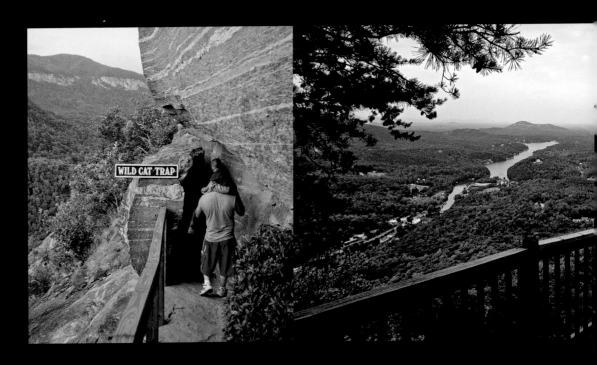

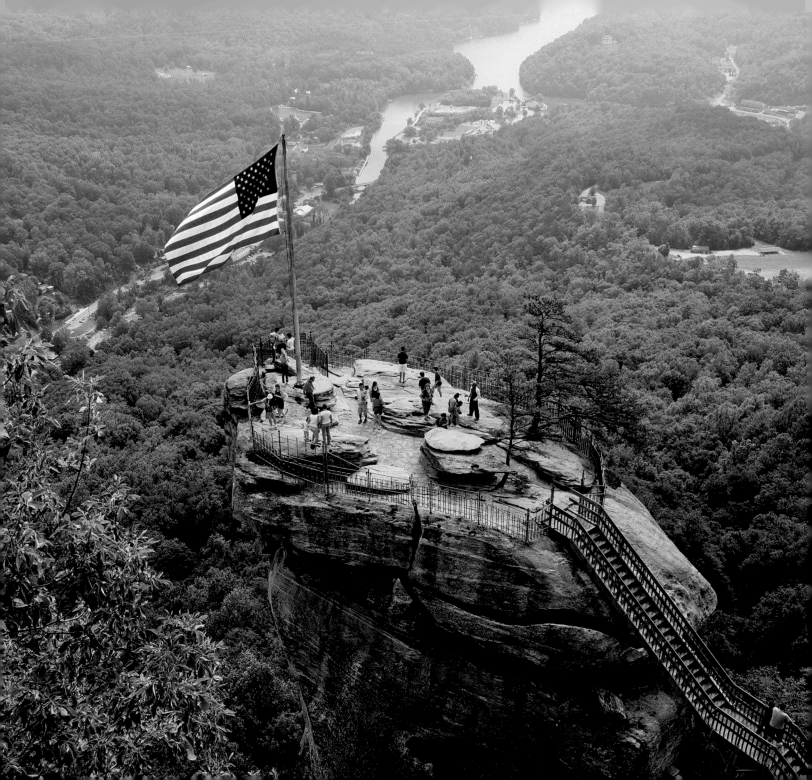

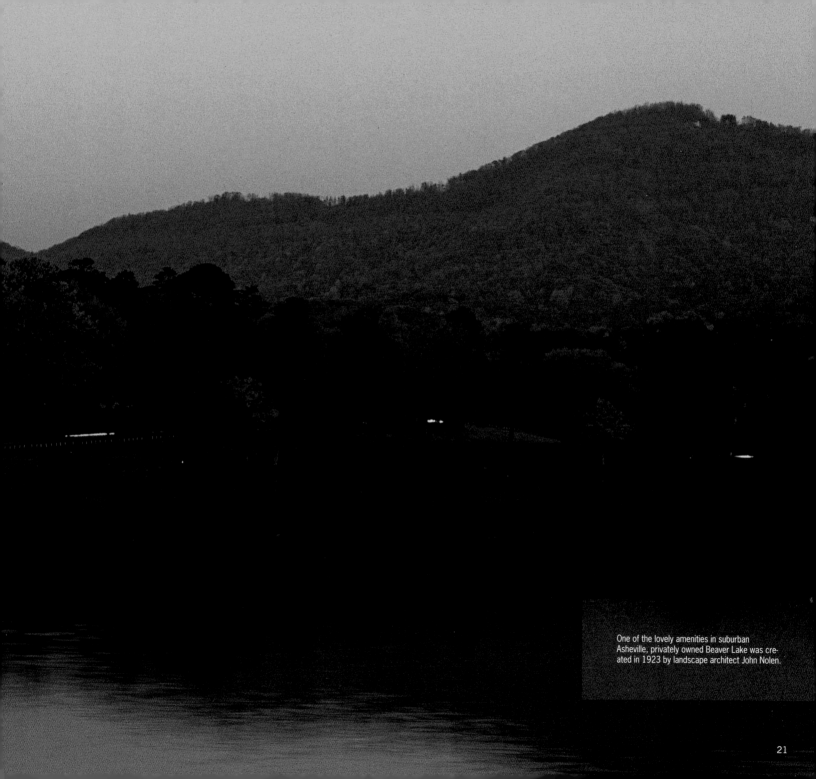

One of the lovely amenities in suburban Asheville, privately owned Beaver Lake was created in 1923 by landscape architect John Nolen.

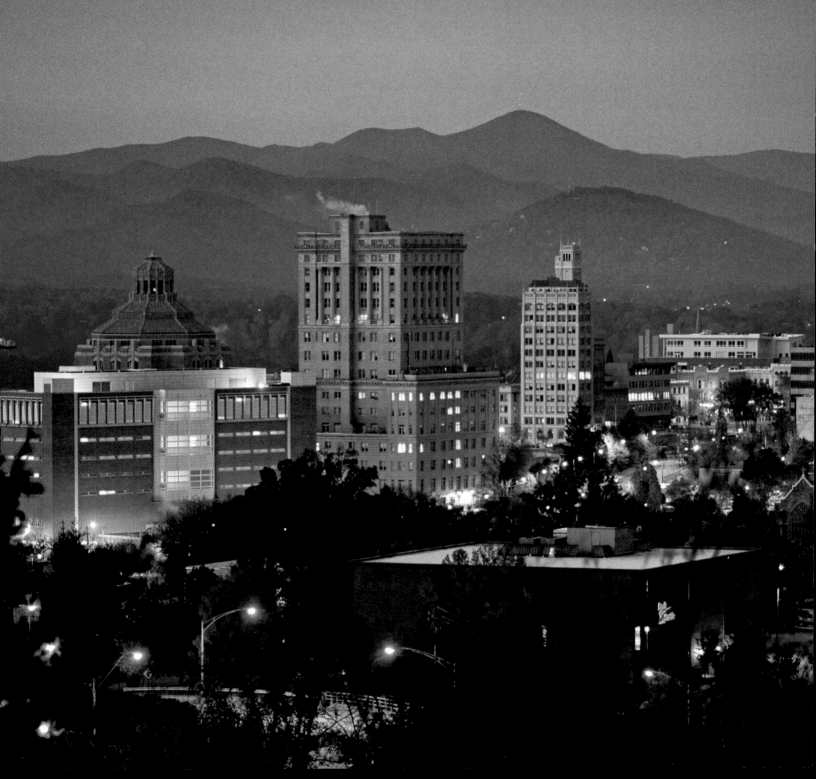

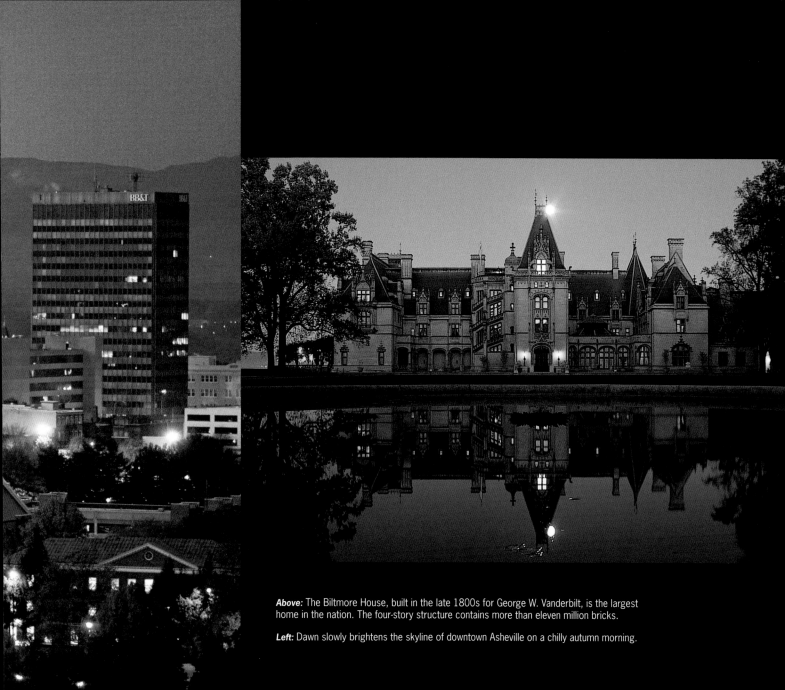

Above: The Biltmore House, built in the late 1800s for George W. Vanderbilt, is the largest home in the nation. The four-story structure contains more than eleven million bricks.

Left: Dawn slowly brightens the skyline of downtown Asheville on a chilly autumn morning.

Below, left to right: The Biltmore Forest School trained students in forestry science and business. Founded in 1898, it was the nation's first forestry school, and now the site is called the Cradle of Forestry. Handwashed laundry hangs on the railing at a forestry lodge modeled after architecture used in Germany's Black Forest. These outposts were located at strategic points where rangers could watch for wildlife poachers and timber thieves.

Right: Today's visitors can see a typical ranger's station at the Hiram King House, in the Biltmore Forest School on the Pisgah National Forest.

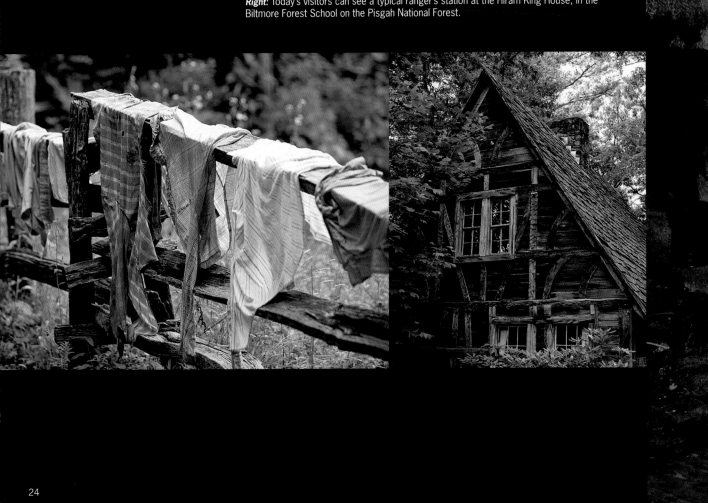

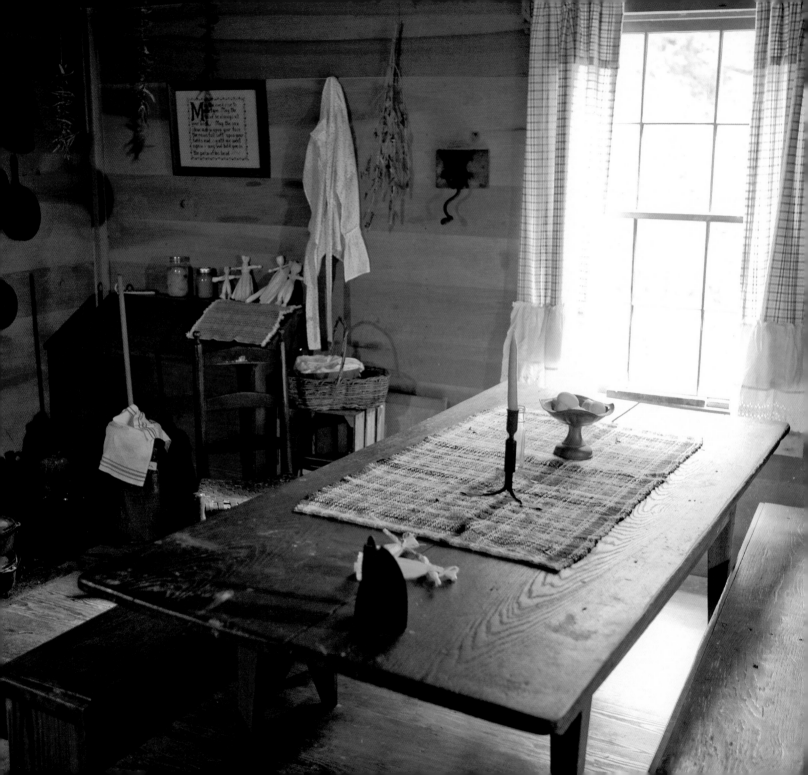

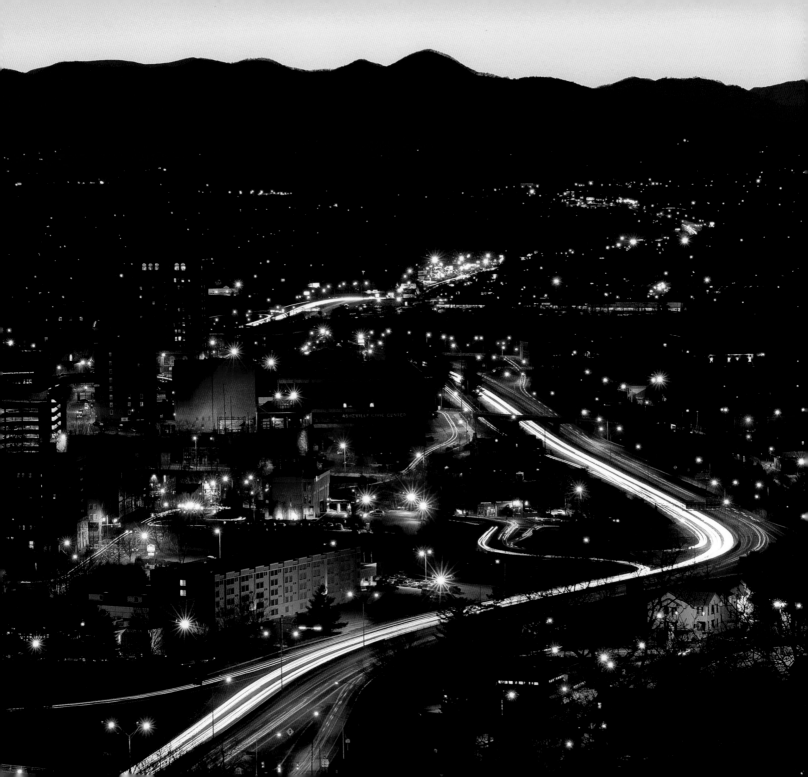

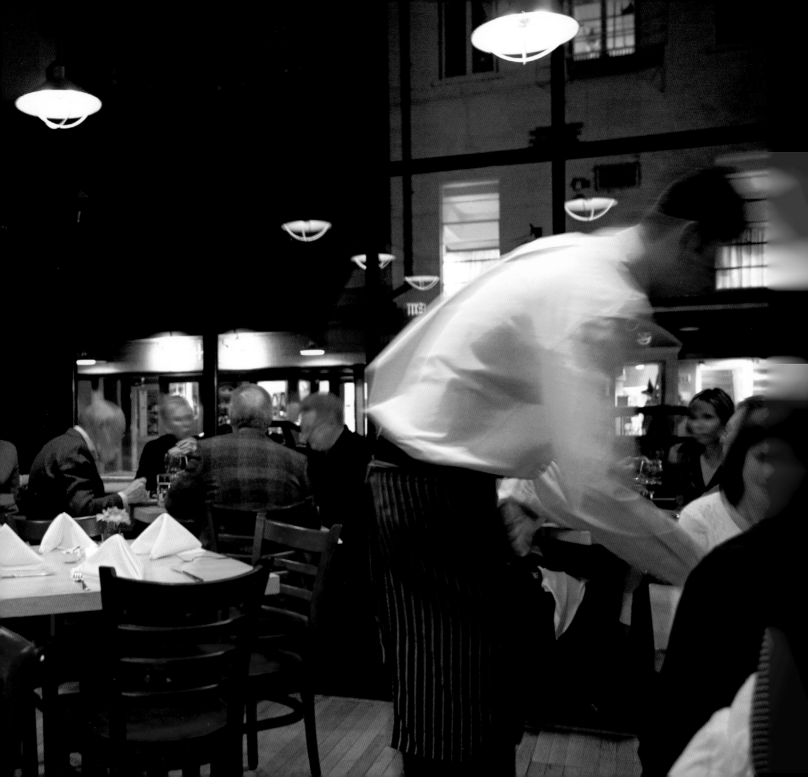

Below, left to right: Soup 'n sandwich is hot and ready at Tupelo Honey Cafe. Izzy's Coffee Den offers breakfasts and lunches, as well as plenty of room to lounge and sip. Savor fresh, local, primarily organic fare at Laughing Seed Café.

Facing page: Frederic Miles carved the limestone frieze on this 1895 Romanesque Revival building in downtown Asheville. It is called the Drhumor Building (pronounced "drummer") after the owner's ancestral Irish island.

Below, left to right: The Asheville Urban Trail, a self-guided tour of downtown Asheville's most significant historical landmarks, provides views of architectural features on the S & W Cafeteria, Grove Arcade, and S. H. Kress & Co. buildings.

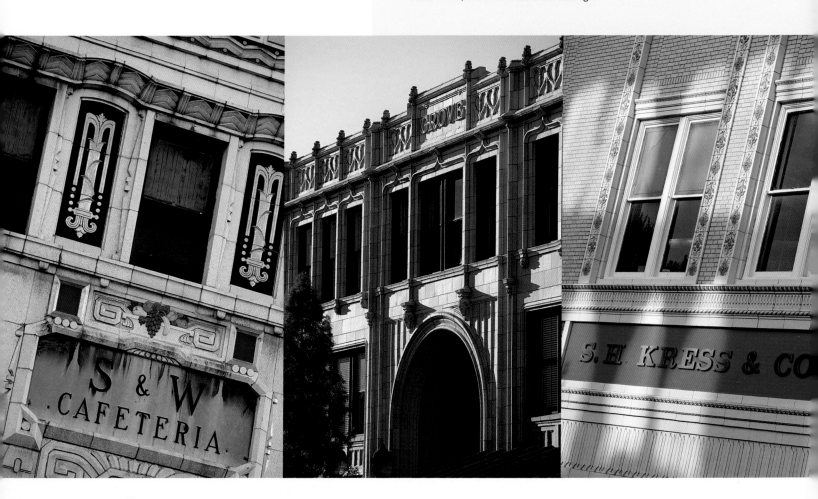

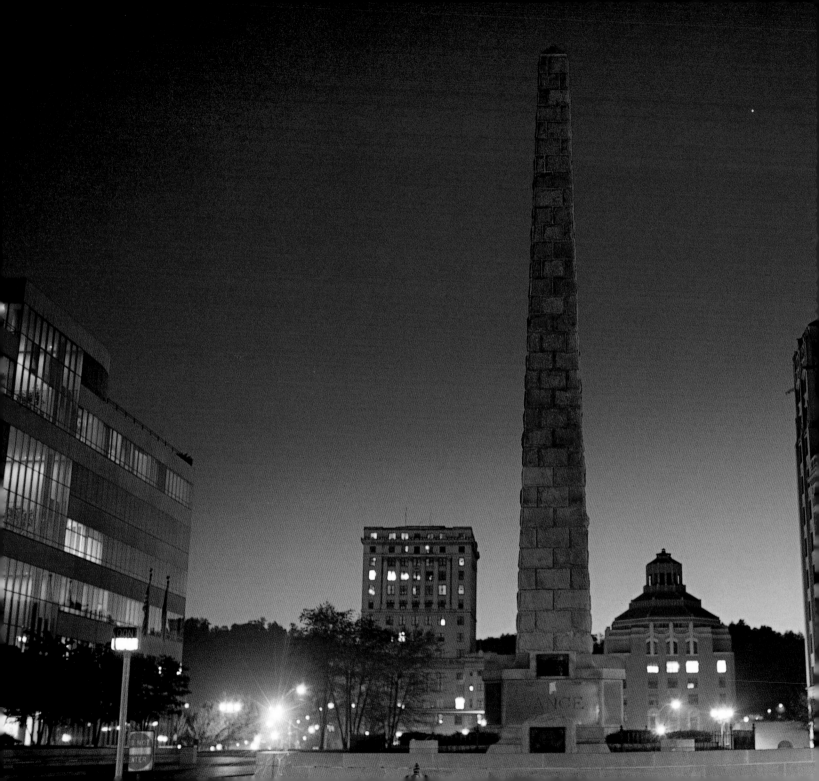

Left: The rough-hewn granite spire of Vance Monument, a tribute to North Carolina's 1860s governor Zebulon B. Vance, is a reminder of the importance of tolerance and inclusiveness.

Below: The Nantahala River is renowned for exhilarating whitewater runs. Here, a kayaker surfs a wave in the river.

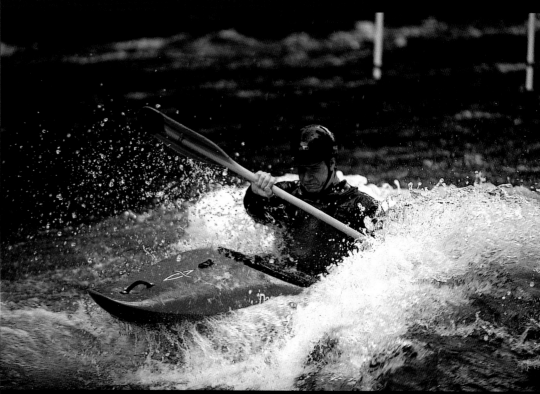

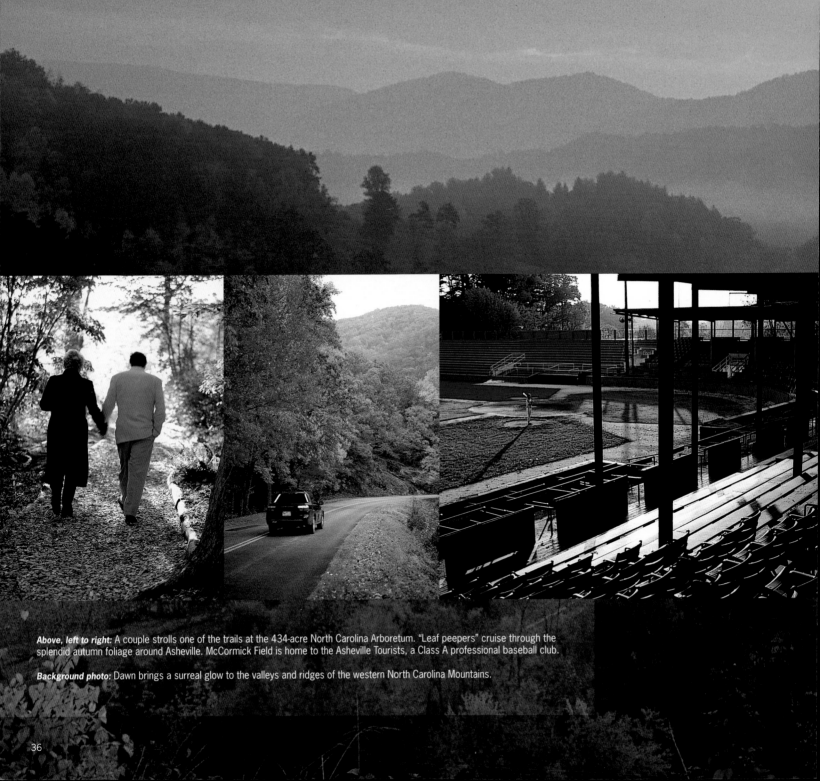

Above, left to right: A couple strolls one of the trails at the 434-acre North Carolina Arboretum. "Leaf peepers" cruise through the splendid autumn foliage around Asheville. McCormick Field is home to the Asheville Tourists, a Class A professional baseball club.

Background photo: Dawn brings a surreal glow to the valleys and ridges of the western North Carolina Mountains.

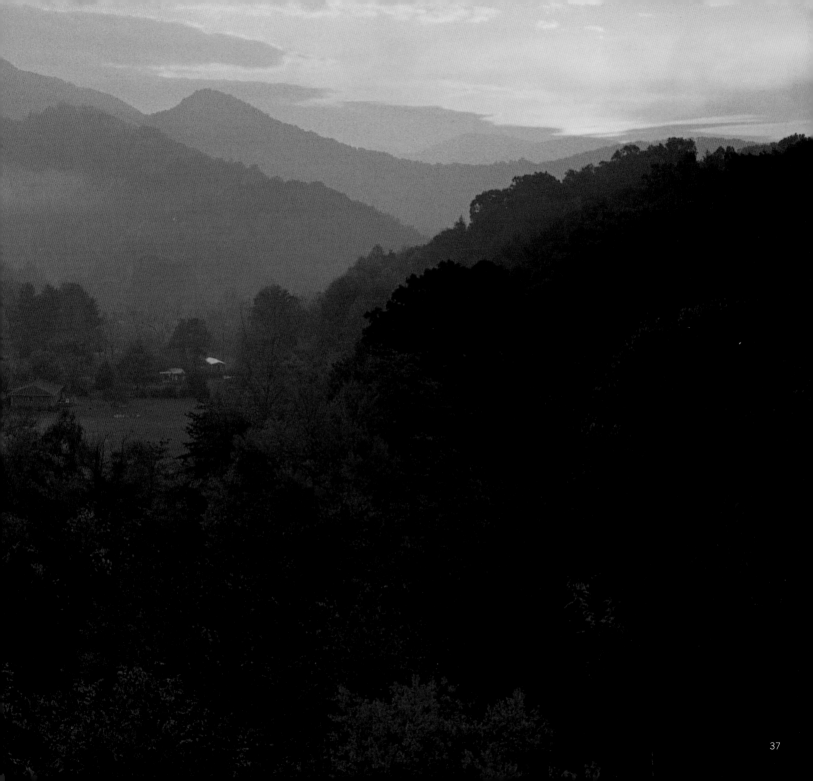

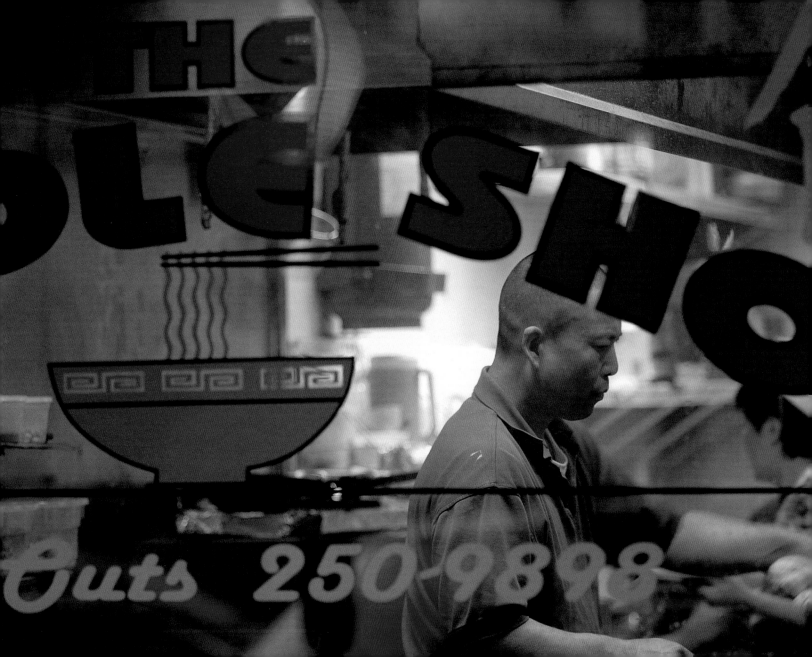

Left: The Noodle Shop, on Pack Square, serves appetizers, soups, and noodle bowls to diners indoors and out. Pack Square, the historic central square in Asheville, is a charming part of the city, named for early booster George Willis Pack.

Below: Perfectly ripe purple string beans fill a basket at a farm stand just outside Asheville.

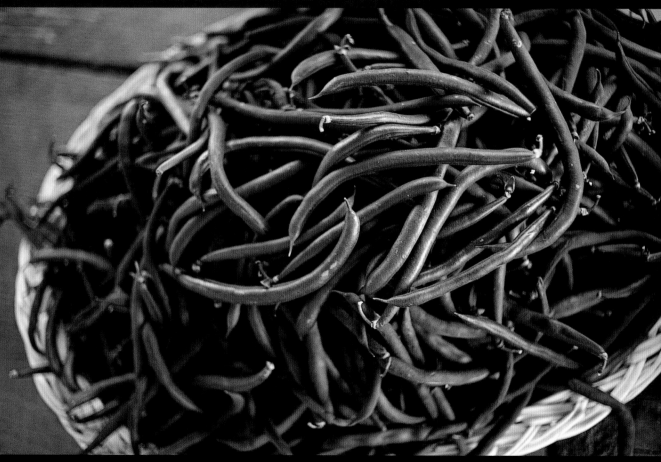

The circa-1840 Smith-McDowell House was Asheville's first brick residence. Now listed on the National Register of Historic Places, and operated as a museum since 1981, the home still contains most of its original Greek Revival woodwork. It served as a school for several decades before being leased and restored by the Western North Carolina Historical Association. Netting or gauze was used in the summers to keep bugs away from fruits and from marring the polished metal finishes.

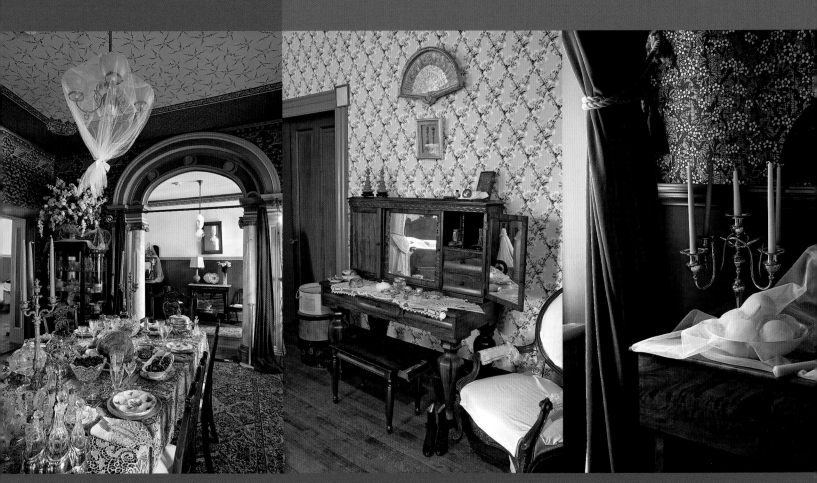

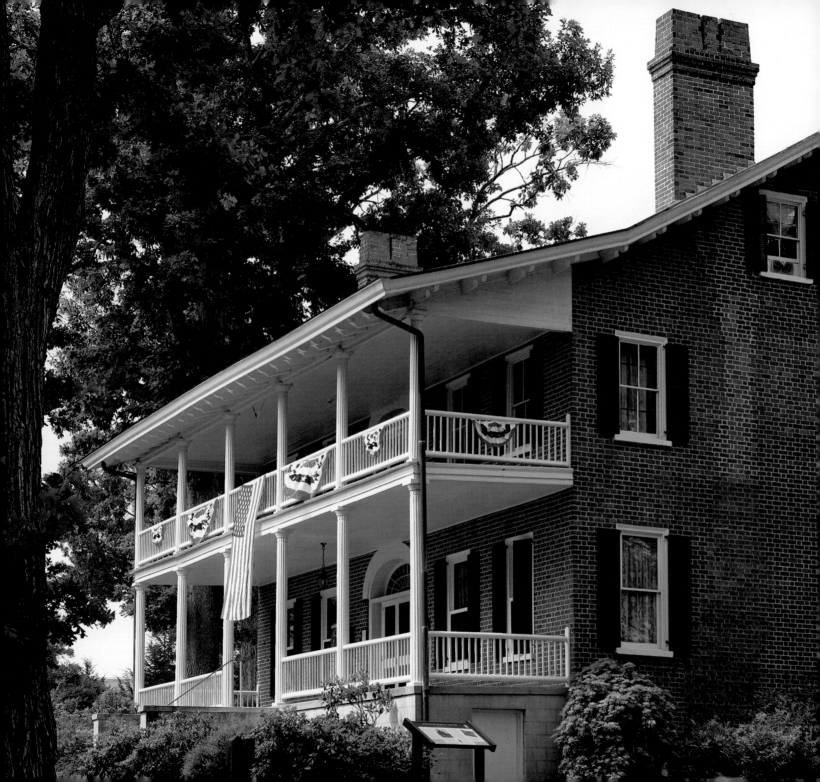

Above: The owner of the Enchanted Light, a candle and lighting store in downtown Asheville, demonstrates the age-old craft of making candles.

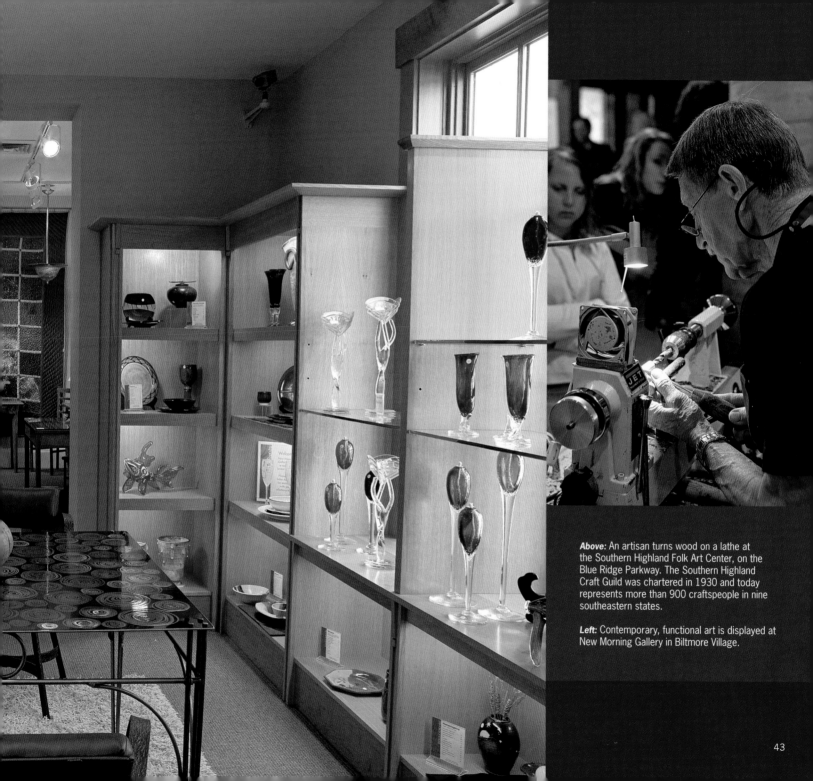

Above: An artisan turns wood on a lathe at the Southern Highland Folk Art Center, on the Blue Ridge Parkway. The Southern Highland Craft Guild was chartered in 1930 and today represents more than 900 craftspeople in nine southeastern states.

Left: Contemporary, functional art is displayed at New Morning Gallery in Biltmore Village.

Above, right: Distinctive buildings mark the skyline in Pack Square, the historic heart of Asheville. Asheville was settled primarily by Scots-Irish immigrants. By 1785 the permanent settlement was known as "Eden Land," then Morristown. In 1797, the town incorporated officially as Asheville for North Carolina Governor Samuel Ashe.

Below, right: William Sydney Porter, who penned stories under the name O. Henry, lived for a time in Asheville. He is commemorated in this plaque on the Urban Trail.

Far right: Early autumn is a fine time to stroll around Biltmore Village. In addition to extensive shops, galleries, and restaurants, the village hosts arts and crafts fairs and other special events.

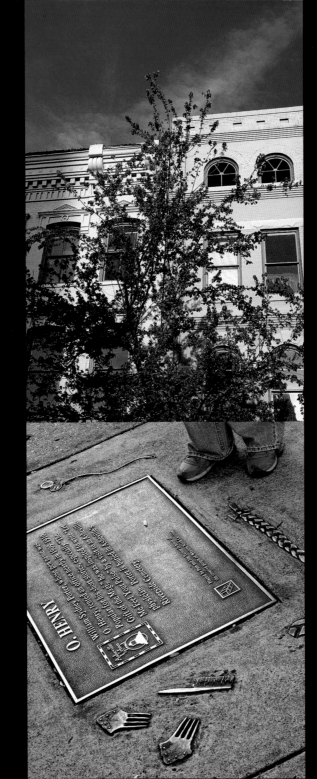

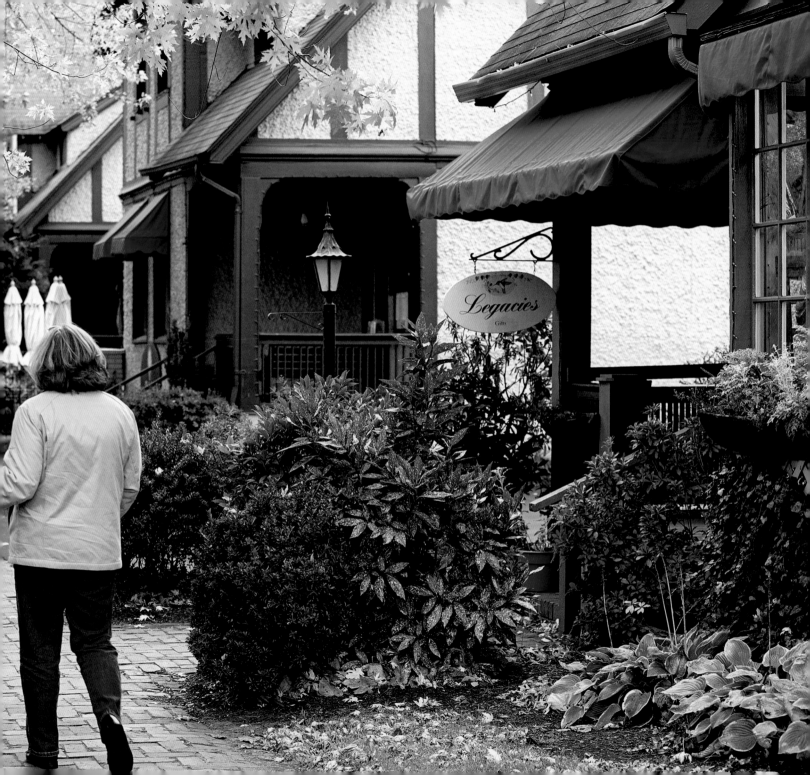

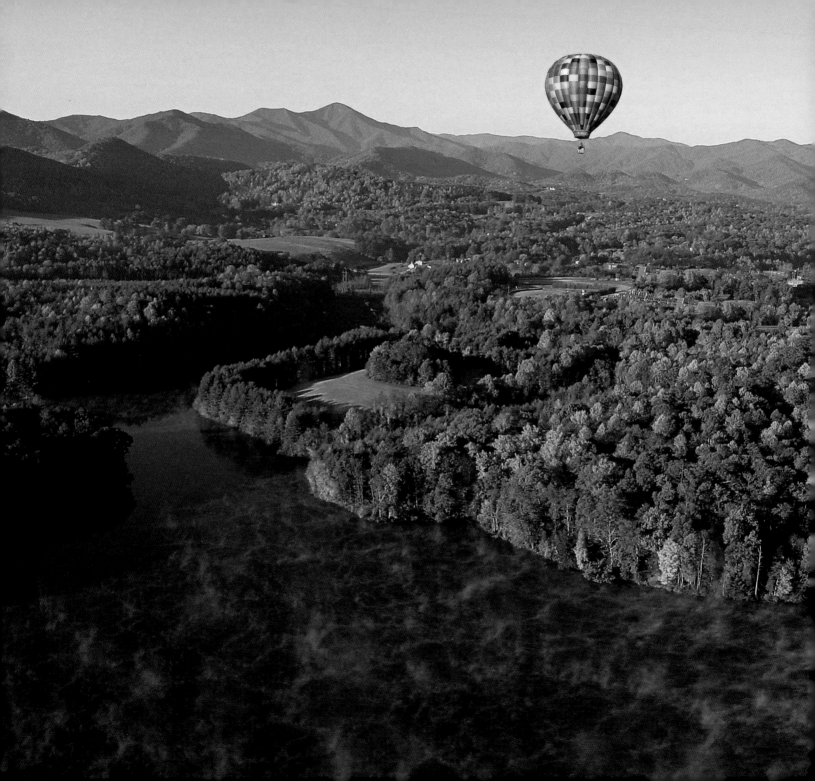

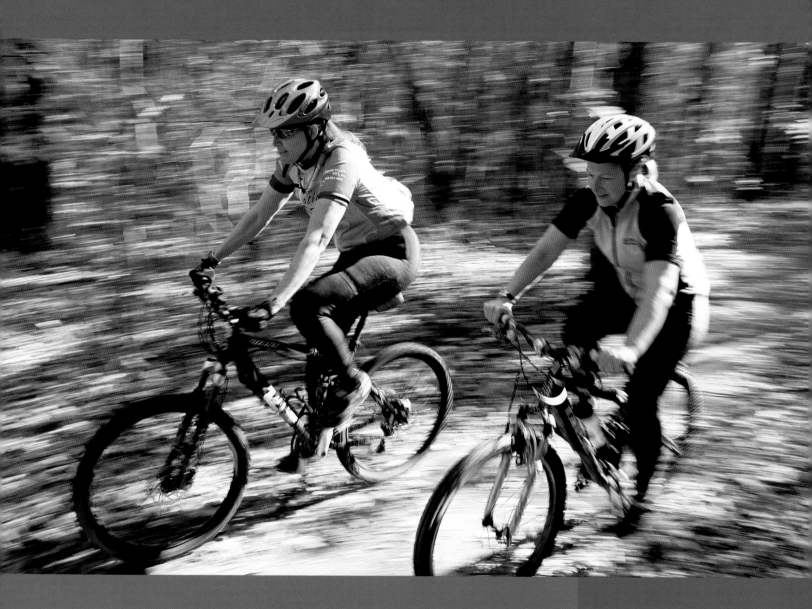

Above: Mountain bikers speed along one of the many trails at Bent Creek, a Research and Demonstration Forest in the Pisgah National Forest near Asheville.

Facing page: A hot air balloon ride is an ideal way to see Asheville and the fall foliage surrounding the French Broad River. Tulip trees and birches turn yellow, sassafras trees glow orange, oaks are more subtle in russet and maroon. Dogwoods, sourwoods, and blackgums provide the deep reds. PHOTO COURTESY OF ASHEVILLE CONVENTION & VISITORS BUREAU

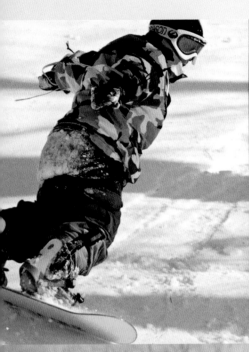
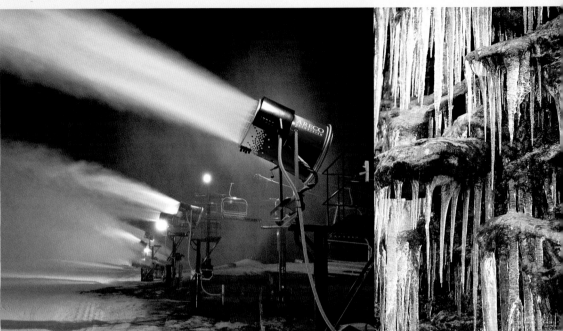

Above, left to right: A snowboarder careens down the slopes at Cataloochee Ski Area. COURTESY OF CATALOOCHEE SKI AREA, MICHAEL MEISSNER, PHOTOGRAPHER
Snow machines make up for any moisture nature might not provide at Cataloochee. COURTESY OF CATALOOCHEE SKI AREA, MICHAEL MEISSNER, PHOTOGRAPHER
Early winter alternates between freezing and thawing, creating these icicles on a rock wall alongside the Blue Ridge Parkway.

Background photo: Heavy frost and ice encase the dense vegetation along the Blue Ridge Parkway. By midday, it will all have melted off.

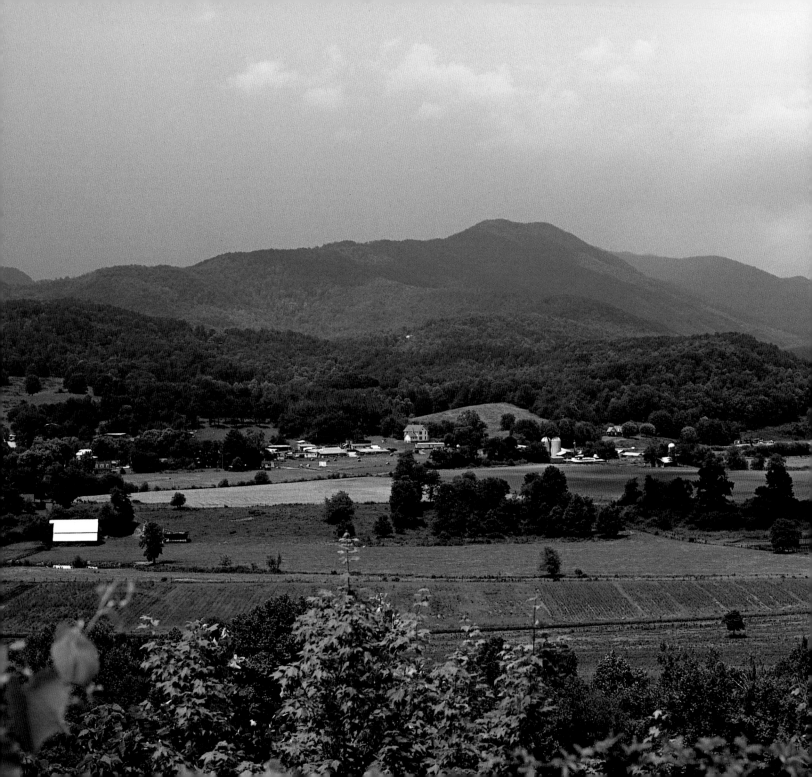

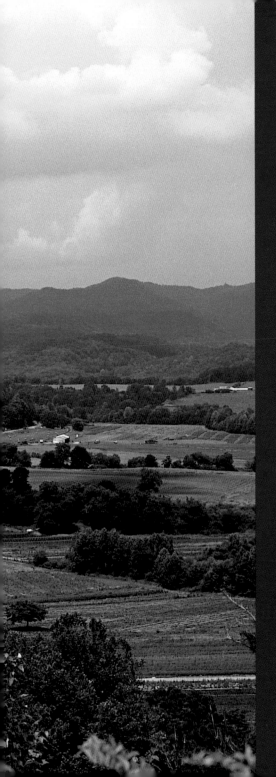

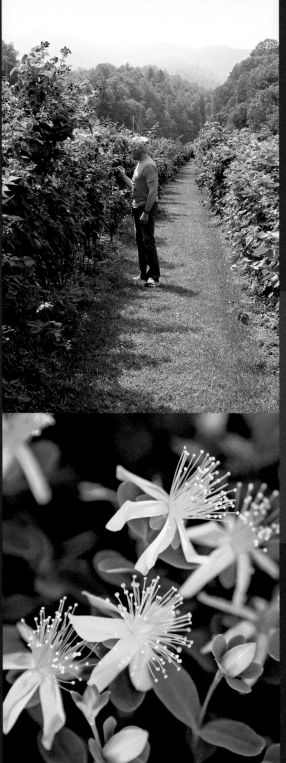

Above, left: The prolific farms around Asheville provide fresh berries, vegetables, and other homegrown produce to thirty-six area markets and numerous local restaurants. The temperate climate and average rainfall of forty-seven inches is excellent for agriculture.
PHOTO COURTESY OF ASHEVILLE CONVENTION & VISITORS BUREAU

Below, left: Saint John's wort grows abundantly along the Blue Ridge Parkway. This native plant has been used medicinally for centuries.

Far left : Crab Orchard Valley maintains a quiet, rural way of life, not far from Asheville.

Facing page: The Grove Arcade offers a classy, outdoor market feel while the skylights protect shoppers from the elements. Originally opened in 1929, the extravagant structure was extensively renovated in the late 1990s and reopened in 2002. Today it houses upscale shops, galleries, and restaurants.

Below, left to right: Clever window displays invite lingering at an antiques store, a dancer's supply shop, and a Grove Arcade shoe store.

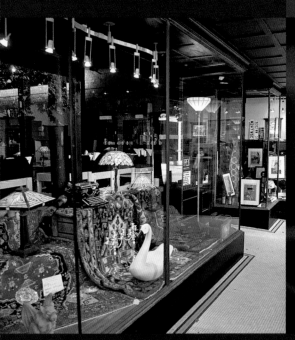

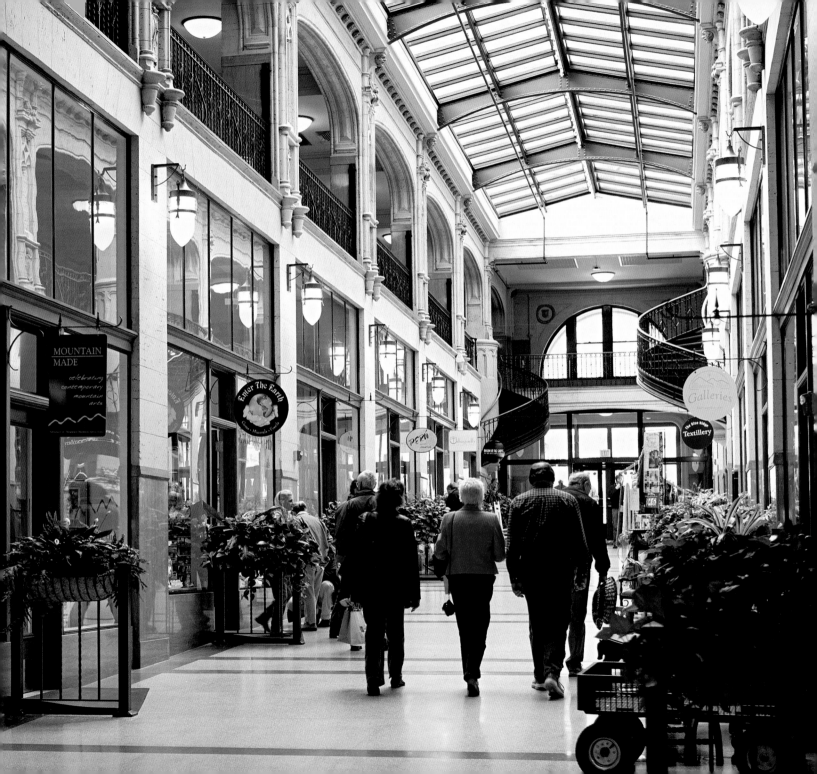

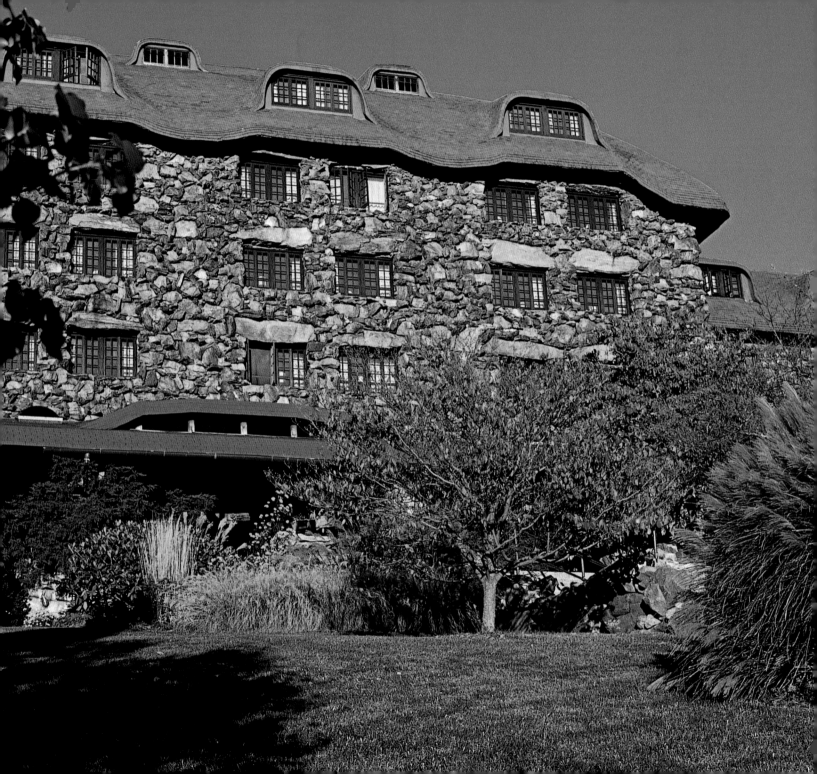

Left: Edwin W. Grove built the Grove Park Inn on Sunset Mountain in 1913. Local, uncut granite boulders protect the structure's walls and chimneys. It served for a time as an internment center; later, the Navy used the building. After major renovations and additions, it now operates as a full-service, deluxe inn and resort.

Below: The Woolworth Walk in downtown Asheville houses more than 150 exhibiting artists. When you're ready for a break, head for the fully functioning soda fountain, and the soda jerk will mix you a real phosphate.

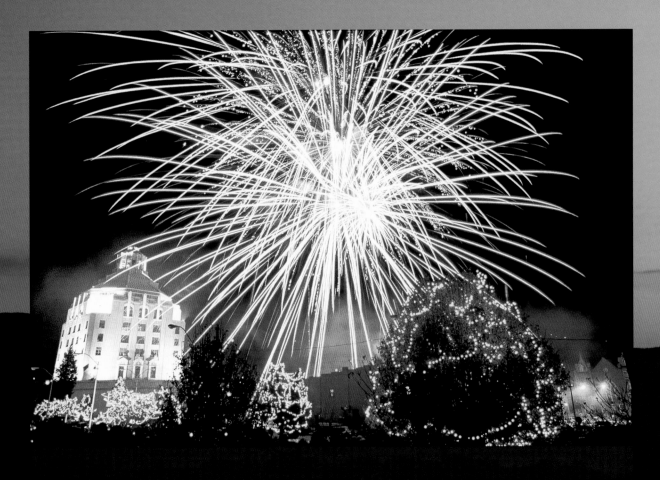

Above: Fireworks are a traditional part of the annual "Light Up Your Holidays" winter festival, which includes music, dance, performances, and caroling. PHOTO COURTESY OF ASHEVILLE CONVENTION & VISITORS BUREAU

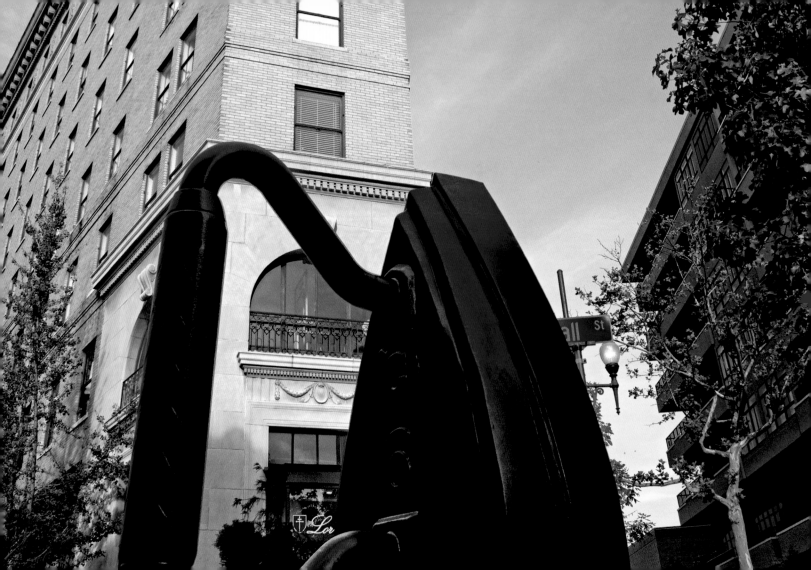

Facing page: A gigantic flatiron sculpture marks the Flatiron Building, at the entrance of Wall Street. The eight-story, narrow ("flat") structure designed by Albert C. Wirth was built during Asheville's boom in the 1920s.

Below, left to right: Thirty sculptures on the Asheville Urban Trail include wild turkeys and musicians. A modern assemblage of used parts creates a focal point elsewhere in the city.

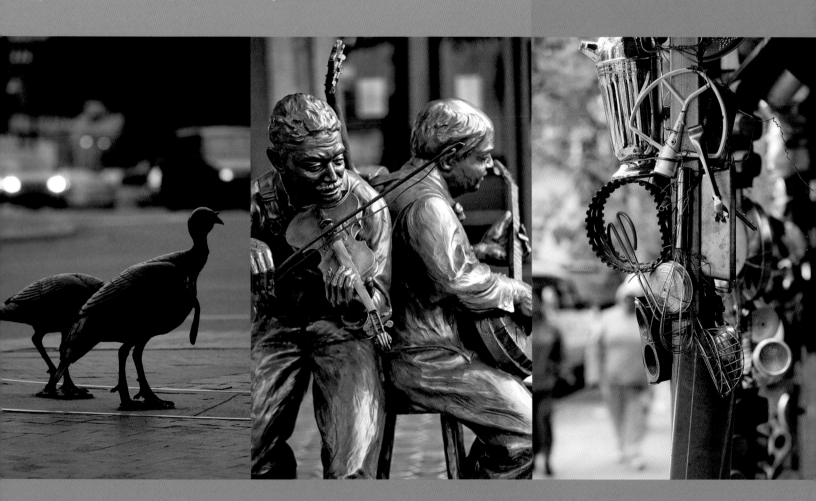

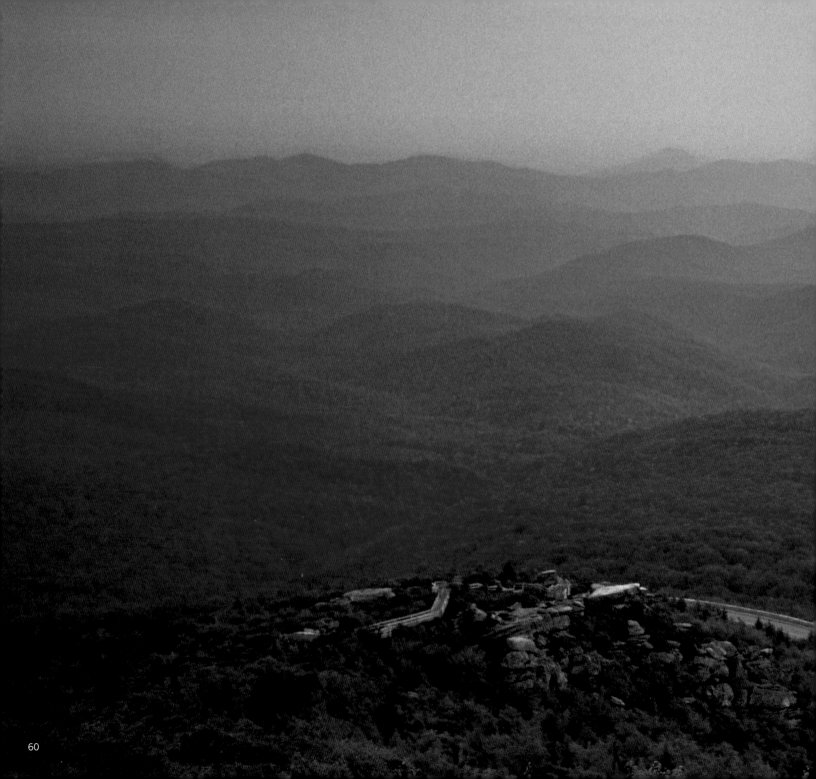

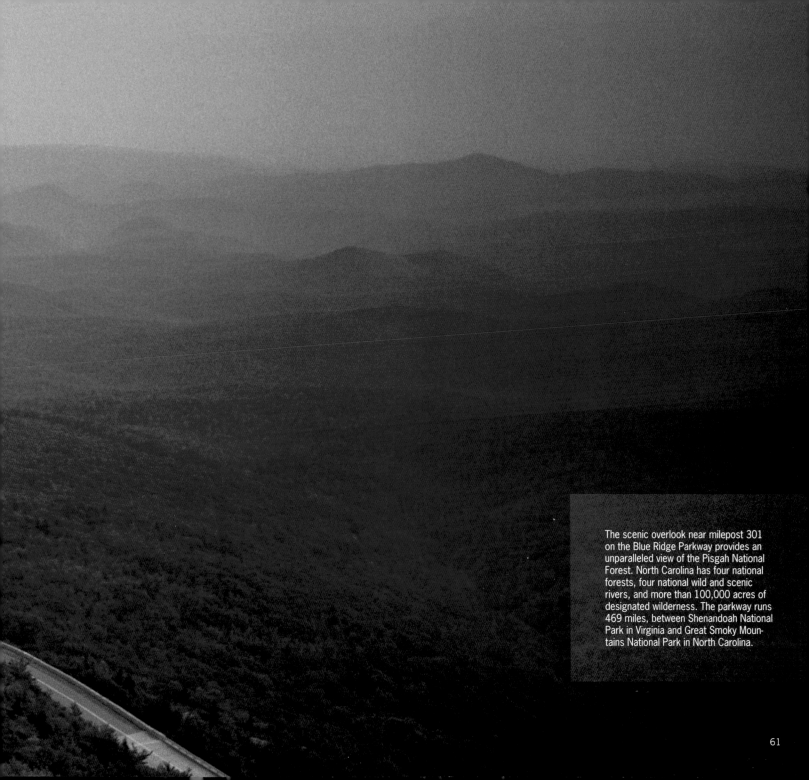

The scenic overlook near milepost 301 on the Blue Ridge Parkway provides an unparalleled view of the Pisgah National Forest. North Carolina has four national forests, four national wild and scenic rivers, and more than 100,000 acres of designated wilderness. The parkway runs 469 miles, between Shenandoah National Park in Virginia and Great Smoky Mountains National Park in North Carolina.

Right: Looking Glass Falls cascades down about sixty feet of smooth granite. It's an easy walk to the base of the falls, and its light, cooling mist in summer is a delight.

Far right: Wahoo! They're lined up and ready for a turn at water-polished Sliding Rock, just a short drive up the road from Looking Glass Falls in the Pisgah National Forest near Brevard.

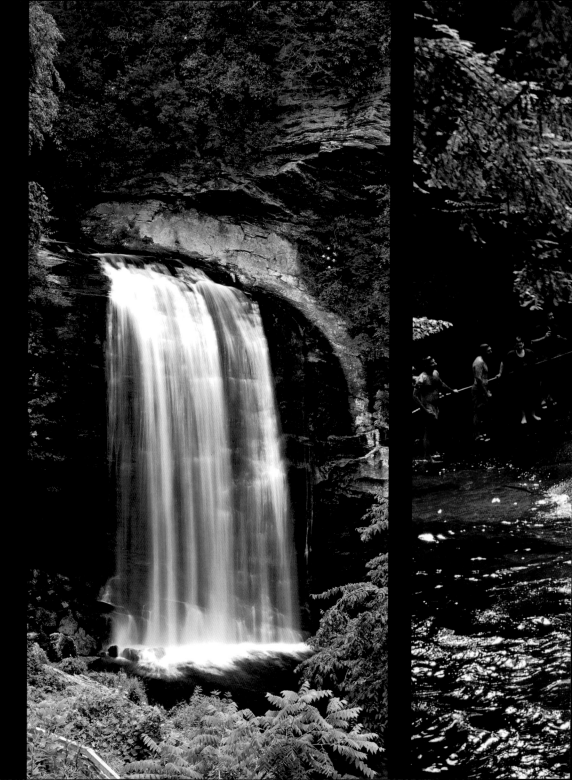

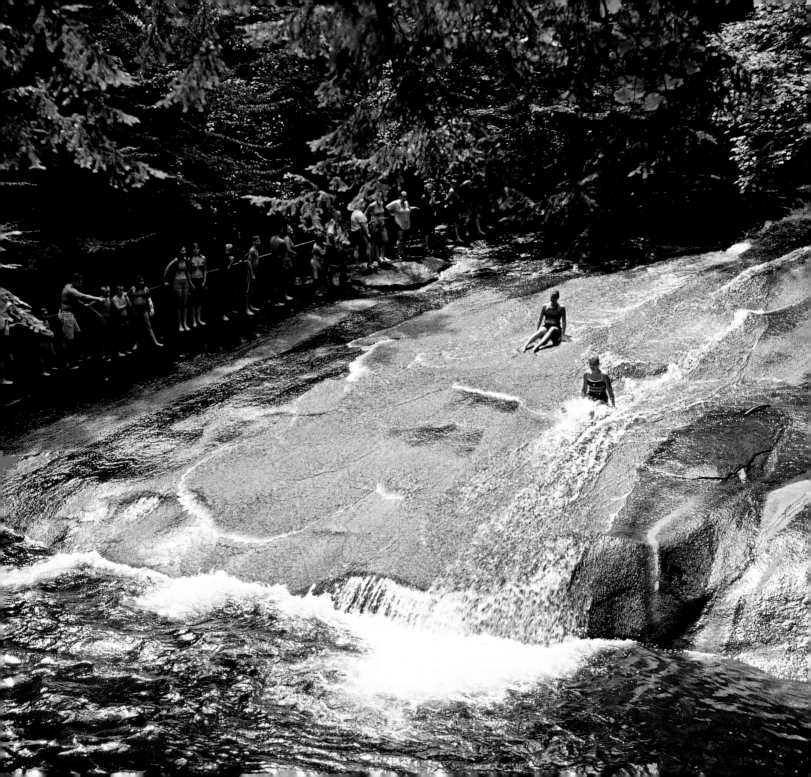

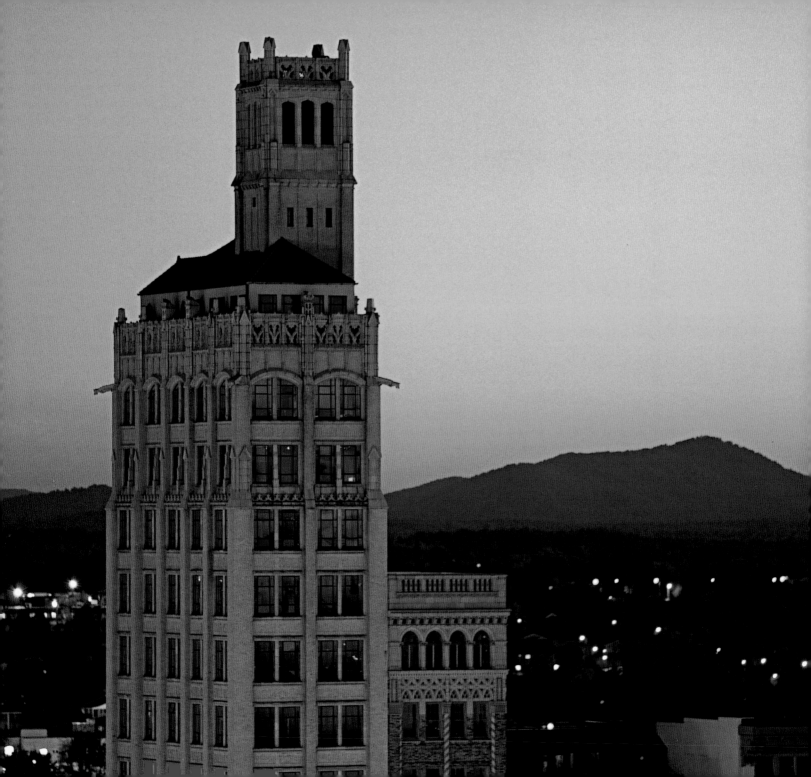

Facing page: City Bakery Café makes diverse, organic, European-style baked goods, as well as other culinary delights.

Below, left to right: A jolly icon welcomes people to Chelsea's and the Village Tea Room, where they serve lunch or a proper English afternoon tea. Biltmore Village's Kismet Café offers dining in an upstairs loft and outside patio. World Coffee Cafe serves outrageous desserts with its classic coffees, just around the corner from Wall Street.

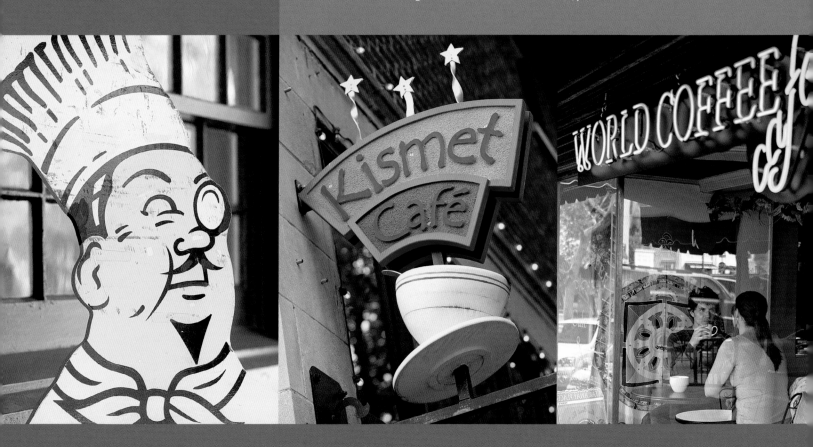

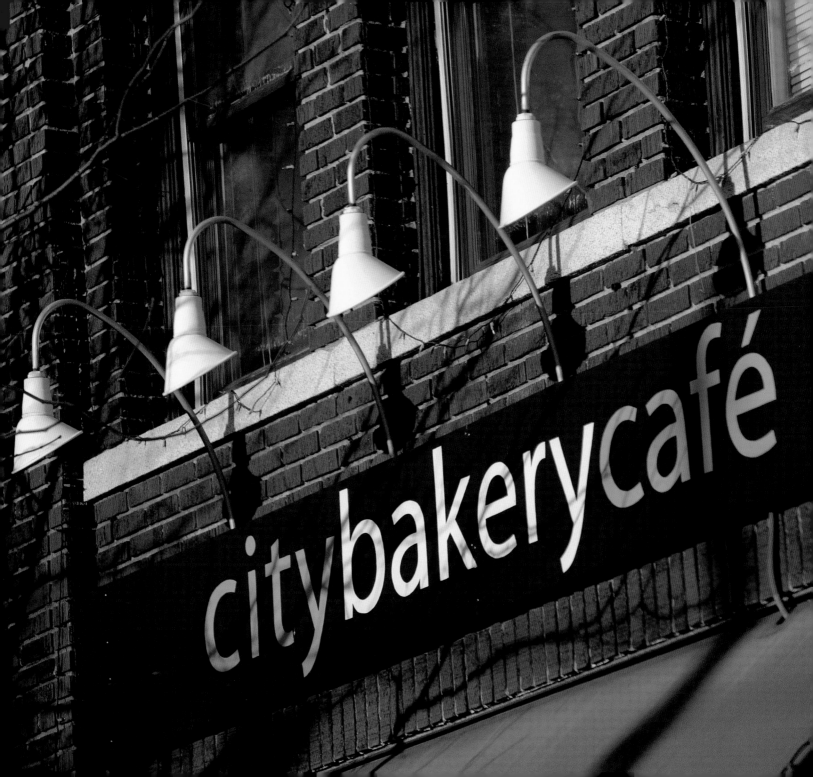

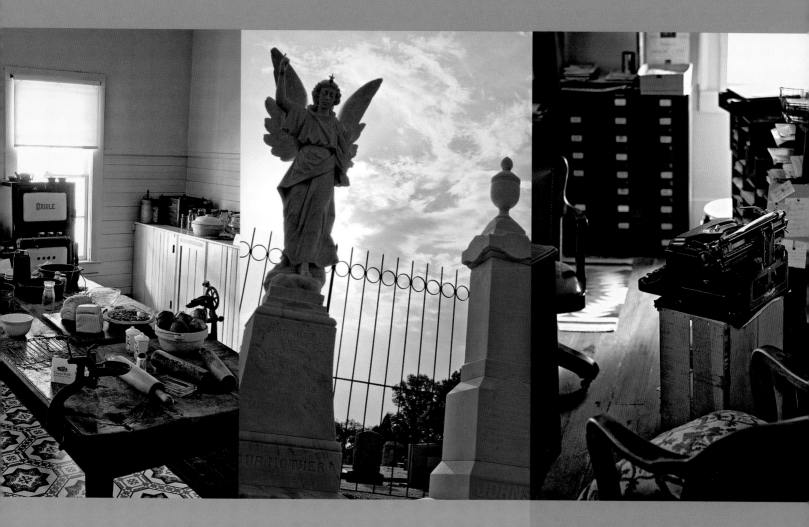

Facing page and above, left: Author Thomas Wolfe was born in Asheville in 1900, and the city serves as the backdrop for his 1929 autobiographical novel, *Look Homeward, Angel*, published just nine years before his death. Now a national historic landmark, the Thomas Wolfe House was originally a boardinghouse run by his mother.

Above, center: The stone angel, featured in Thomas Wolfe's title, stands in Hendersonville's Oakdale Cemetery, south of Asheville. It was carved by his father, a stonemason.

Above, right: Carl Sandburg would write all night in this small upstairs office on Connemara Farm, in Flat Rock, with his typewriter perched atop an orange crate. His wife operated a premier dairy goat operation here.

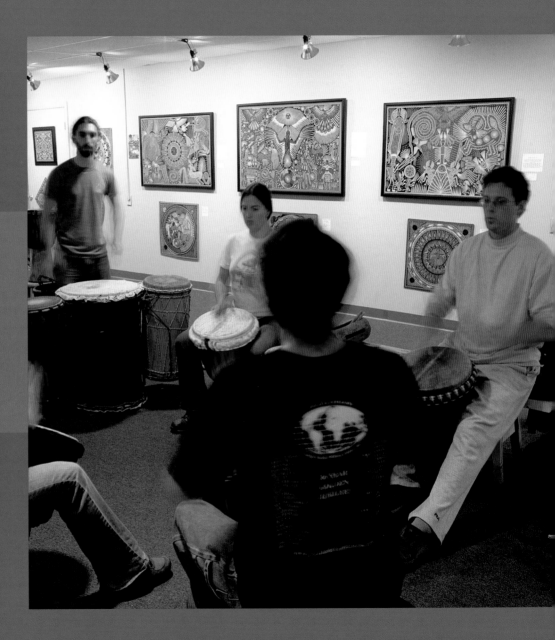

Right: Drummers learn new rhythms at Skinny Beats Drum Shop & Gallery. The shop has percussion instruments from djembes to gongs.

Facing page: In 2006, *Outside* magazine rated Asheville the best whitewater town in the country. Here, rafters on the Nantahala River paddle toward rapids.
PHOTO COURTESY OF ASHEVILLE CONVENTION & VISITORS BUREAU

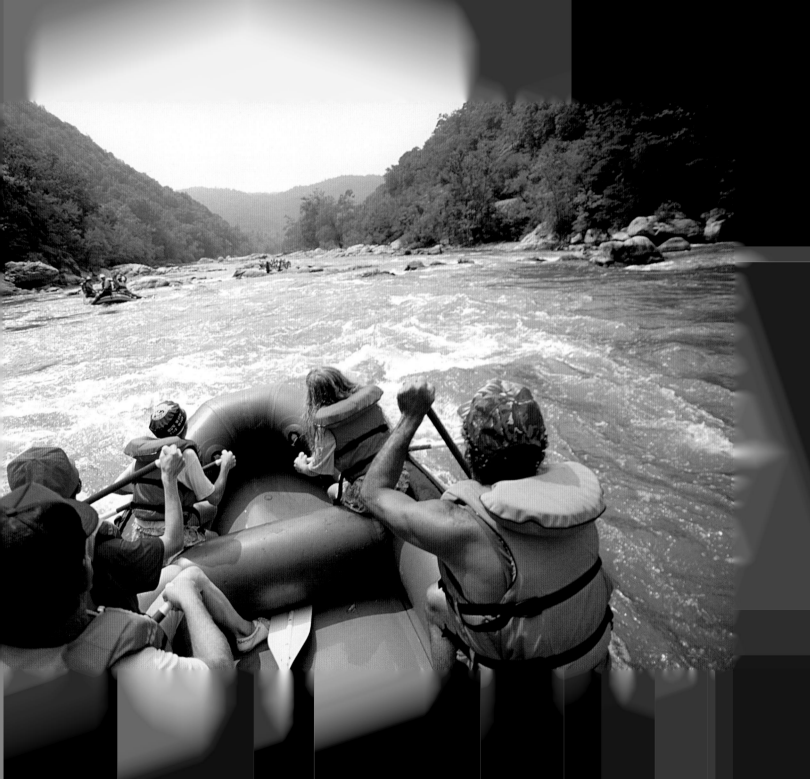

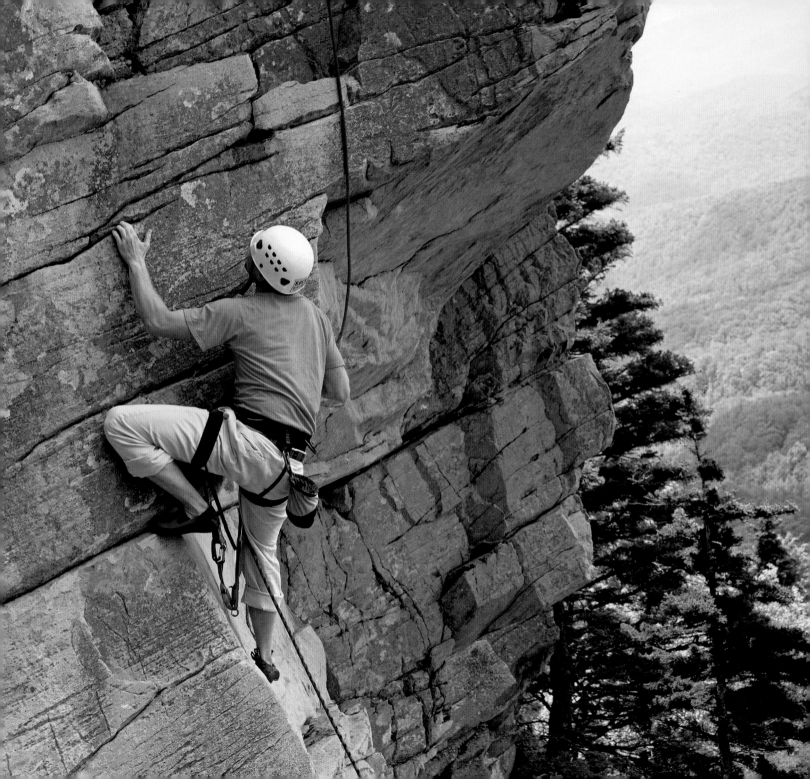

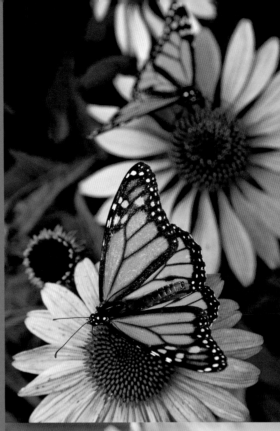

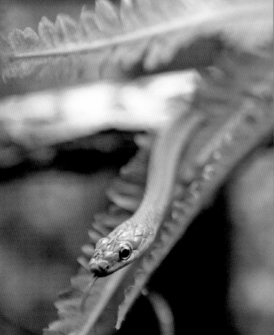

Above, left: These butterflies at the Western North Carolina Nature Center are probing for nectar. The center educates the public about flora and fauna in North Carolina, both present-day as well as species that no longer exist in the region.

Below, left: A harmless rough green snake peers out from a camouflaging fern at the Western North Carolina Nature Center.

Far left: The abundant granite in western North Carolina is popular with rock climbers. Exhibits at the Colburn Museum downtown demonstrate the unique geology of the area.
PHOTO BY SCOTT LESSING HUBENER

Right: One of more than thirty art galleries downtown, Blue Spiral 1 gallery showcases contemporary arts and crafts.

Below: The art deco Fine Arts Theatre features first-run, independent, experimental, and documentary films in the heart of downtown.

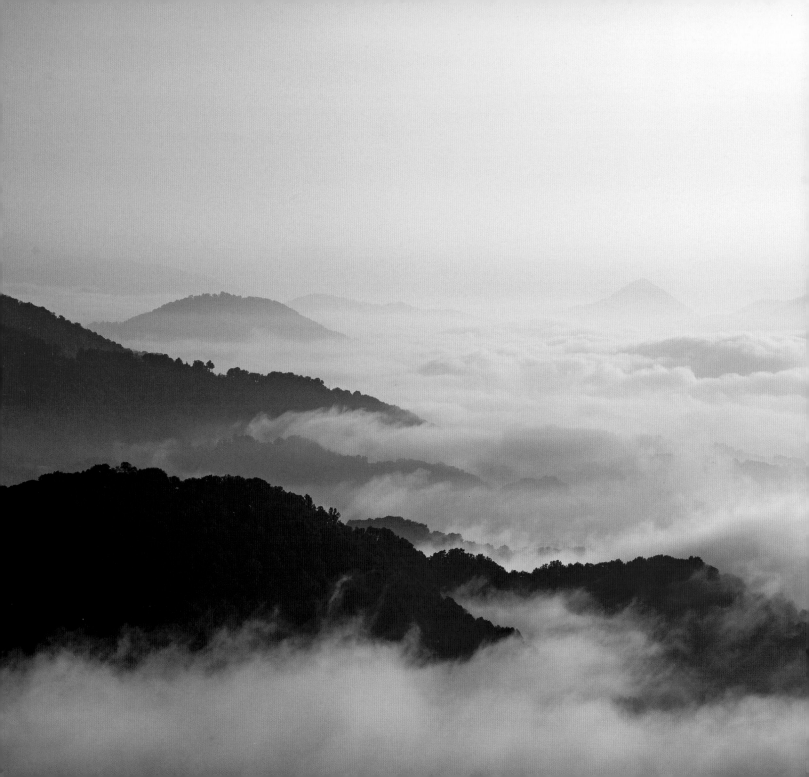

Facing page: This view from the Blue Ridge Parkway makes it easy to understand why Asheville is a premier tourist destination.

Below, left to right: The Little River flows through the mixed hardwood forest in DuPont State Forest in the Blue Ridge Mountains. This great rhododendron is in full bloom. Triple Falls is one of six major waterfalls in Dupont State Forest.

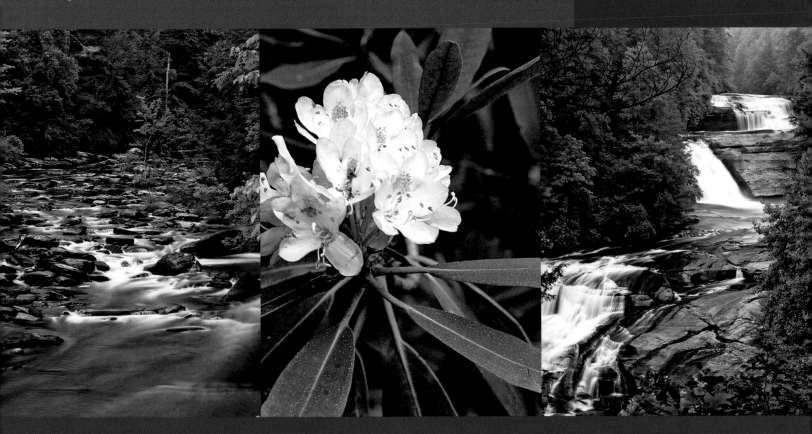

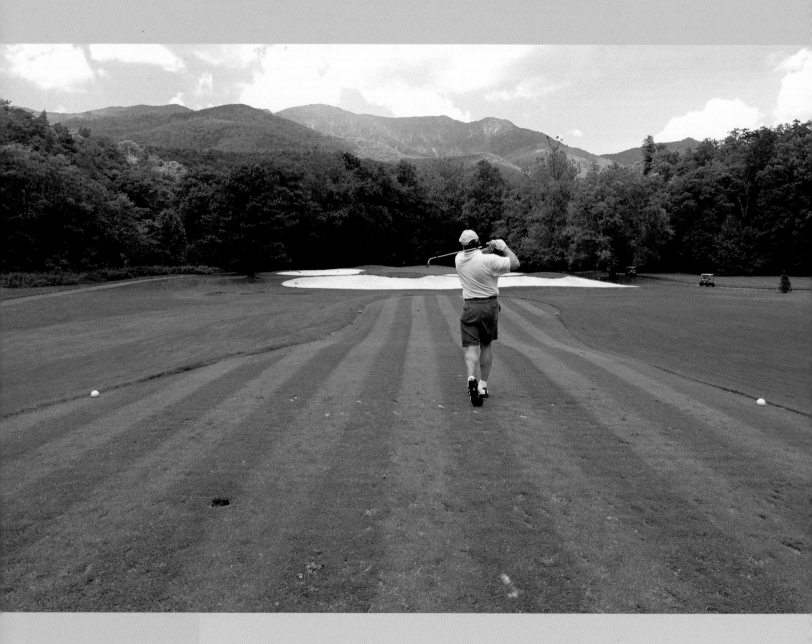

Above: At least twenty courses in the vicinity of Asheville take golf to new heights. PHOTO COURTESY OF ASHEVILLE CONVENTION & VISITORS BUREAU/BILL RUSS

Facing page: Springtime blossoms compete with reflecting panes of glass for your attention. PHOTO BY SCOTT LESSING HUBENER

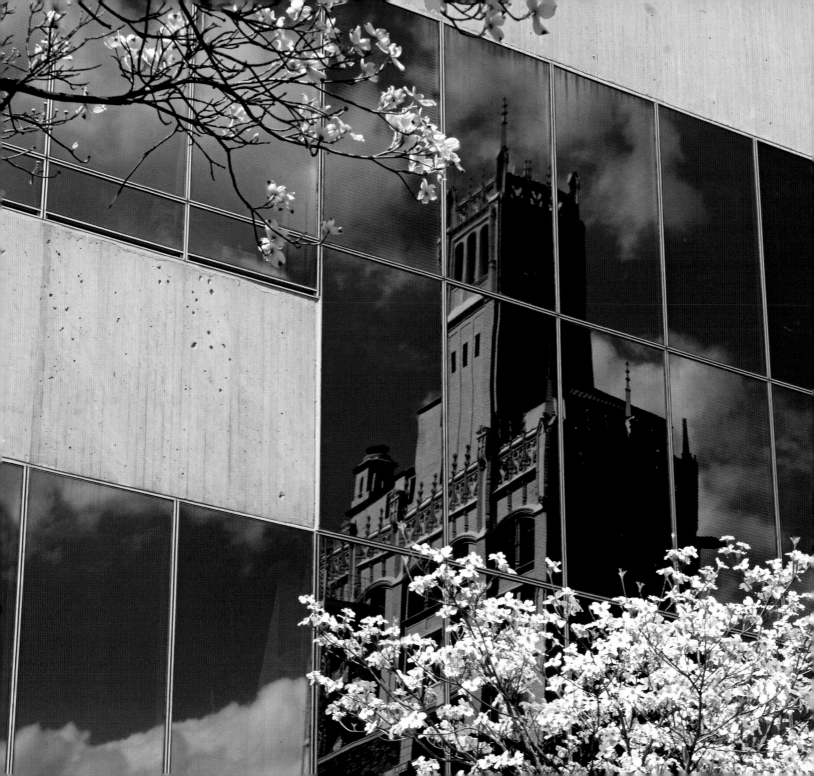

During his 25 years as a commercial photographer, Bob Schatz's photographs have appeared in numerous publications, including *Elle, Forbes, Fortune, National Geographic Traveler, The New York Times Magazine, Newsweek,* and *PC Week*. He has produced advertising and corporate photography for Toshiba, Arkema, Honeywell, Pinnacle Financial, Gresham, Smith & Partners, Tuck Hinton Architects, British Aerospace, Dollar General, Lifeway, DuPont, and SunTrust Banks. His photographs have won regional and national awards.

Schatz, who specializes in location photography, has captured a variety of subjects on film, from images of people in everyday life to portraits of corporate executives, from wide-angle photographs of buildings to close-ups of fishing reels. The 200,000 images in his stock photography files have been used in annual reports, books, brochures, magazines, and on the internet.

Over the years, Schatz has won numerous awards and commissions for his fine art prints, which have been exhibited around the country. His photographs are part of permanent collections at the Cheekwood Fine Arts Center, the Frist Center for the Visual Arts, the Metro Nashville Arts Commission, the Nashville Public Library, and the Tennessee State Museum. His portfolio can be viewed online at www.stockschatz.com.

Right: The three waterfalls at Graveyard Fields are on the Yellowstone Prong of the Pigeon River. According to one story, the area was named around the turn of the century for the many tree stumps that looked like headstones.

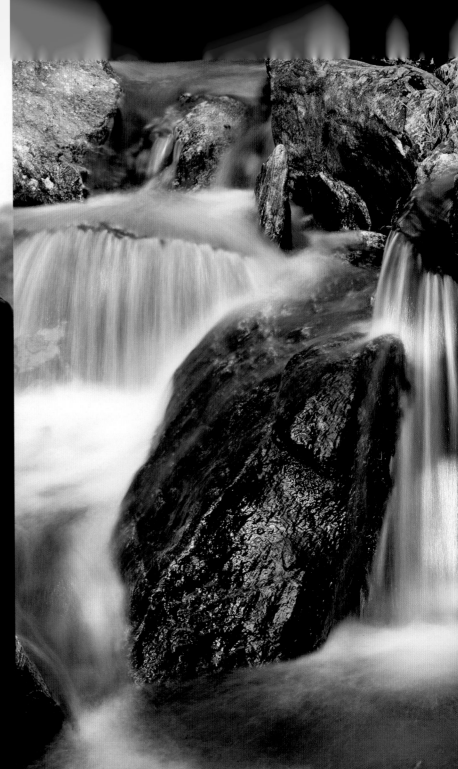